Under the Banner of Concern

Under the Banner of Concern

Tim Presley

Anthology Editions
New York

Writing to you from inside a pandemic as these drawings and poems
take on new meaning. Screenshot headlines like: "THIRD OF WORLD
POPULATION UNDER LOCKDOWN." Dood. I knew you'd been talking to
society and all, self-reflexively, and that life can be a hard pill to swallow
with continued swagger and artistry, especially without Valeries. Glad you
gave them up. But wow, now a lot of these poems look like direct discourse
with a nasty virus. Moving on in a second, but c'mon I'm social distancing
in my Mojave Dez RV rn, mid-sand, face masks, sanitizer, gloves, massive
piles of toilet paper, *Dune*-apocalypse ready, canceled everything. We all
hopped into digital like our lives depend on it, (hopefully) computers
(and we) don't die or infect, so I hear you man, *It's Hard to Believe There's
Something Wrong in Those Nice Little Phones.* But solidarity in isolation?
I don't buy it. Isn't that what social media is failing to sell us, anyway?

> *When I Wake Up*
>
> *You've got to have kidding me*
> *You have got to be kidding me*
> *You've got kidding to give me*
> *You've got kidding to be me*
> *Have you got me kidding?*
> *I am rice*

*

> *fuck you forever*
> *and ever*

Totally fuck that. You remind me I'm human, portraying actual people,
being together, using haptic pencil and ink. The mark-making and
figuration have quick gesturing with special attention to muscle tone,
but distorted proportions, stretched and twisted limbs, often heavy-duty
cheekbones that mash-up Grace Jones, bruises, and werewolf-eye black.
Angular humans touching each other, humorously tiny penises, Cubist
/ oceanic, there's sex but these register not so much as orgy fantasies as
admiring flesh roadmaps, posing athletically. Celebrating bodies. This is
why I call it "classical" work, like you said in a letter:

ive always been enamored with Greek mythology and ancient art. i think subconsciously, because i took myself out of the stream/hustle, i identified with greek sculptures of male/female. the strength they outwardly showed, but were standing alone . . . possibly in some type of conflict or peace. a bit of a contradiction, or maybe i projected that? i can't put my finger on it. or maybe, searching for something good & pure like the human body, symbolically.

*

i am a Greek god
the god of an island of pleasure and escape
only I cannot escape
this is "the tragedy"

*

I need eyes and brain to touch
We don't need much do we?

These poems resonate because they universalize personal duress; we all have antagonistic forces that make us feel like rice. This collection functions, in part, as a spell cast against negatives, a warding-off. Discombobulated typography mixing cursive with box letters, black with outlined white, size variants, slashes and dashes: the syntax is highly legible yet dissociative. Is it negative to dwell on the forces we wish to diminish, to let them direct us toward tunnel openings? No, it's paradoxical medicine. I like how this book avoids avoidance and rearranges anger into a wellspring of fun, sex, and play. *You are angry OK & it's my pain OK.* The poems and drawings Greek-out meaning through hieroglyphic combinations of text and image: graphic reversals, innovative punctuation, mask-wearing characters, rearranged faces: it's representational Rubik's cube realism mired in disorientation. Pertinent letter-intel continued:

this whole body of work revolves around a theme or time period of me getting off Opiates. Or as my Mom calls this time "The Troubles" (she's mostly Irish ha.) i Left LA and returned back to SF to rehabilitate. i had no interest in writing music, so i picked up a paint brush again, and used it as a type of quiet, or therapy. this is all from 2015–2019. this was a very big time for me,

my relationships, and family. i was lucky to have people there for me, and people who among the noise, let me be quiet and exercise these demons out. the only way i felt satisfied with myself was painting, day & night. i felt like i blew up my life in a way, and the only way i could communicate with myself or the world was writing words or painting. it's kinda funny how you actually need to become creative whilst going through a traumatic time. and much like the early White Fence songs, i made all this with zero intent on sharing. i just needed to do it.

*

i need accurate

Lastly, a note about the ultrarelevant examination of public versus private herein. You're really good at differentiating selfhood (owning self, owning angst, owning lines) and external world: *To an Enemy, Send Them Whiskey*. Yet if I had to note one motif questing through this picaresque antinarrative, I'd call it Desire to Connect. Ironic, because many of the poems chronicle attempted correlations between isolated thoughts. But set against cool crews of peeps hanging and groping, I feel welcomed into survivor's brain, and an invitation to strange occasions. Thank you and celebrate, making it out alive again and again.

Becoming normal for nothing but OK need a day dripping on a raven

*

I See You, Freedom

(All italic text Tim Presley's, collaged from this collection and his letters.)

When I Wake Up

You've got to have kidding me
You have got to be kidding me
You've got kidding to give me
You've got kidding to be me
Have you got me kidding?
I am rice

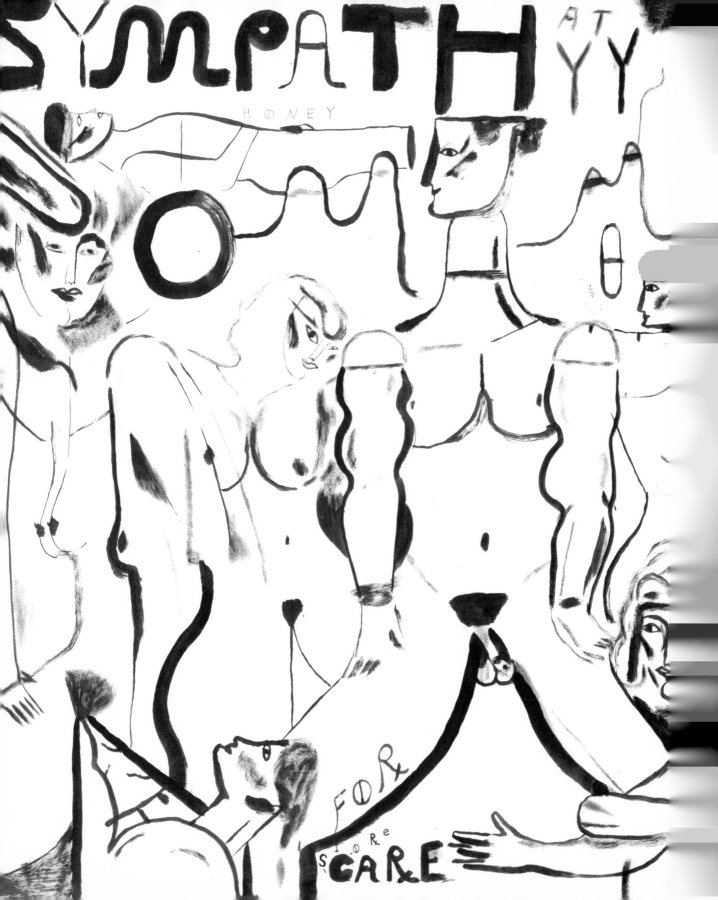

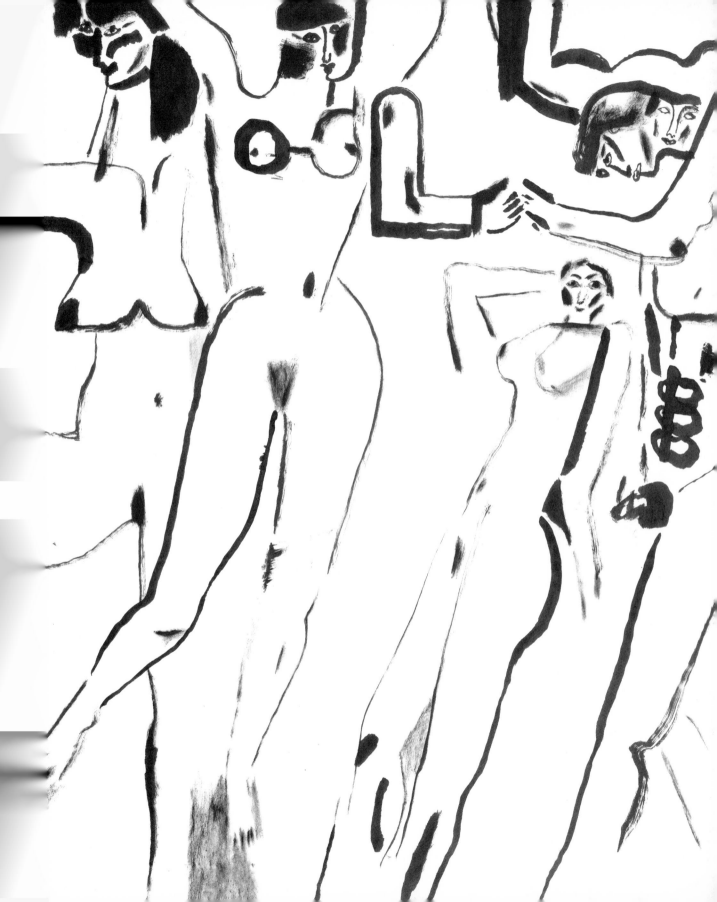

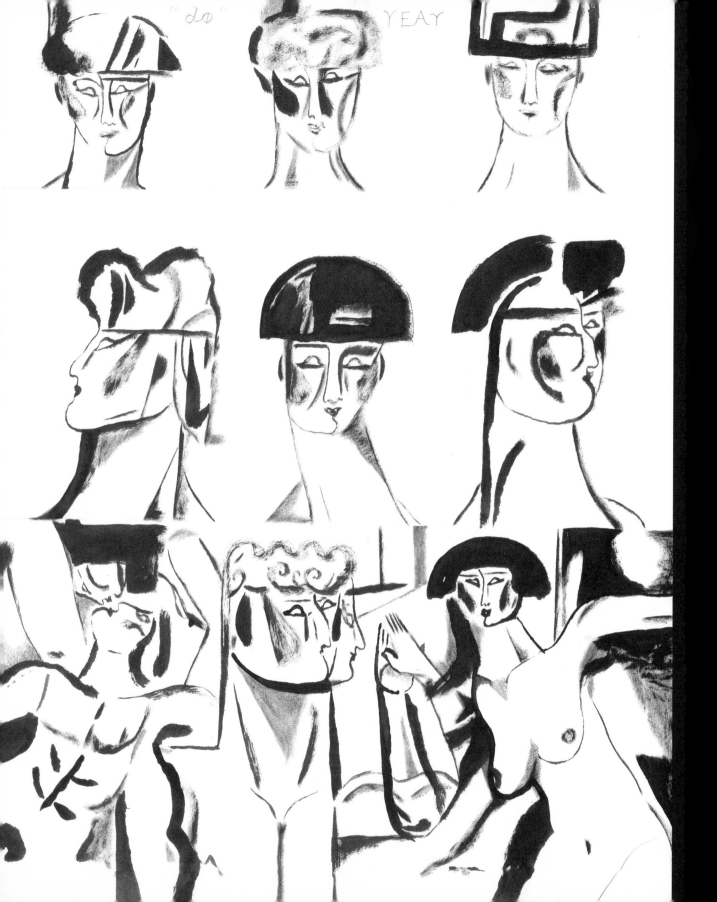

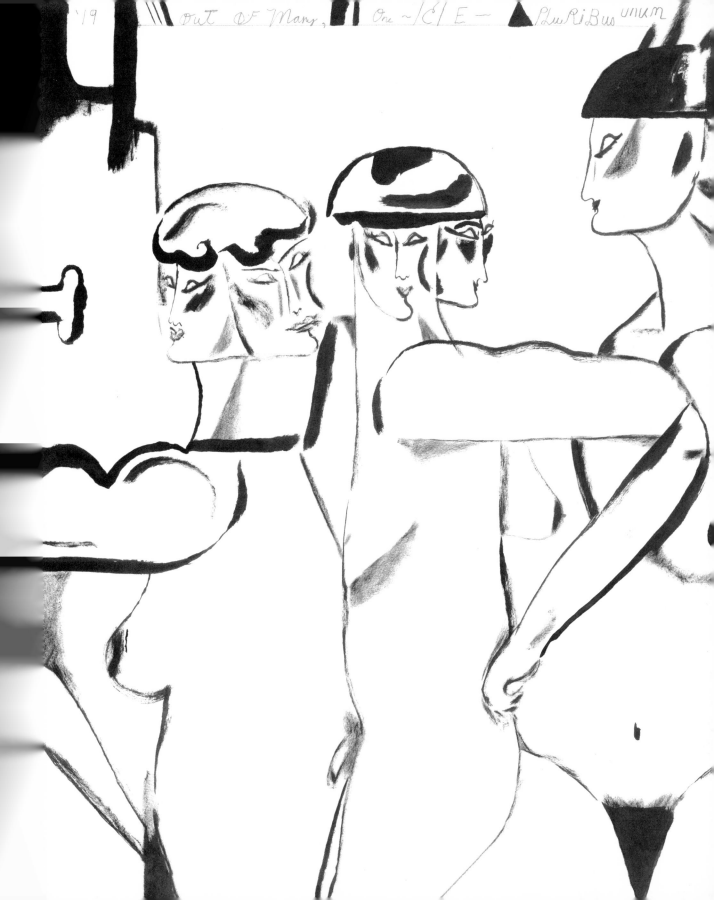

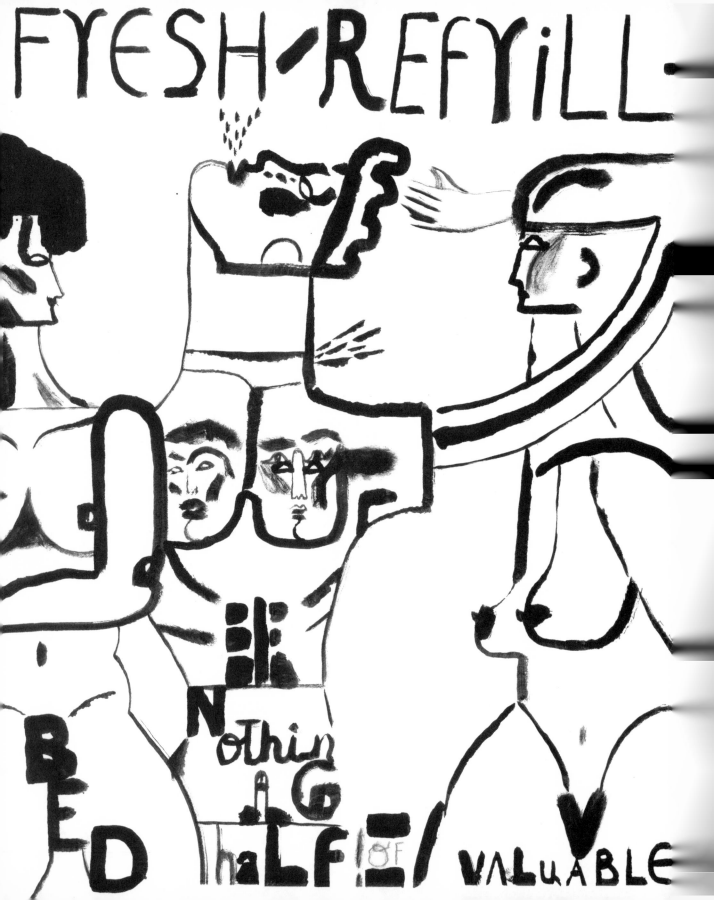

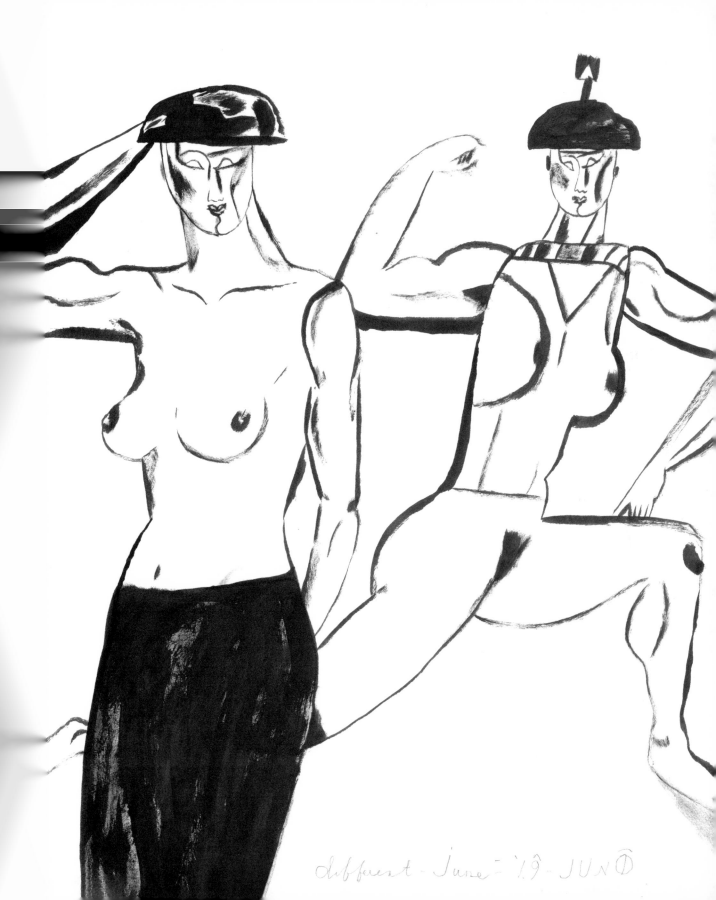

different - June - '19 - JUNO

All the Children's Books Come from Acid

All children's books
come from acid
Illegal things that move you
Yes, you are the problem
after years of the solution
But it's too late to stop you
You are present in the paper
The times that we live off of
Have cut the butter longways
And I didn't know,
you loved him

All the tricks you play on boredom
Have turned to an addiction
And how long can you play
The endless game of drawing circles

There's a feeling of a new town
Every time I see her
Every egg decision
Can crack between the fingers
And I look into this mirror
And I'm not sure I can trust you
If I never cracked her
Well, there's thirteen hundred losers
That walk her to the cliff
That aren't afraid to watch her
I float within the fallen
What did we all learn as children?
A true dull butter knife of loss
Eat the honey, trap
Hidden in a tree
What did we all learn as children?
And,
I kidnapped your answer.

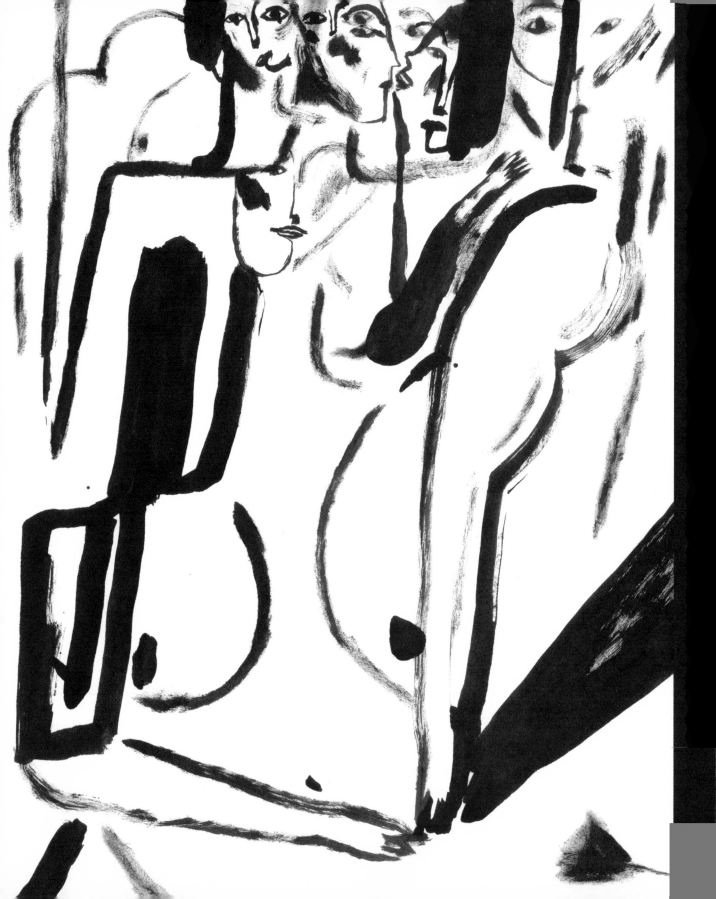

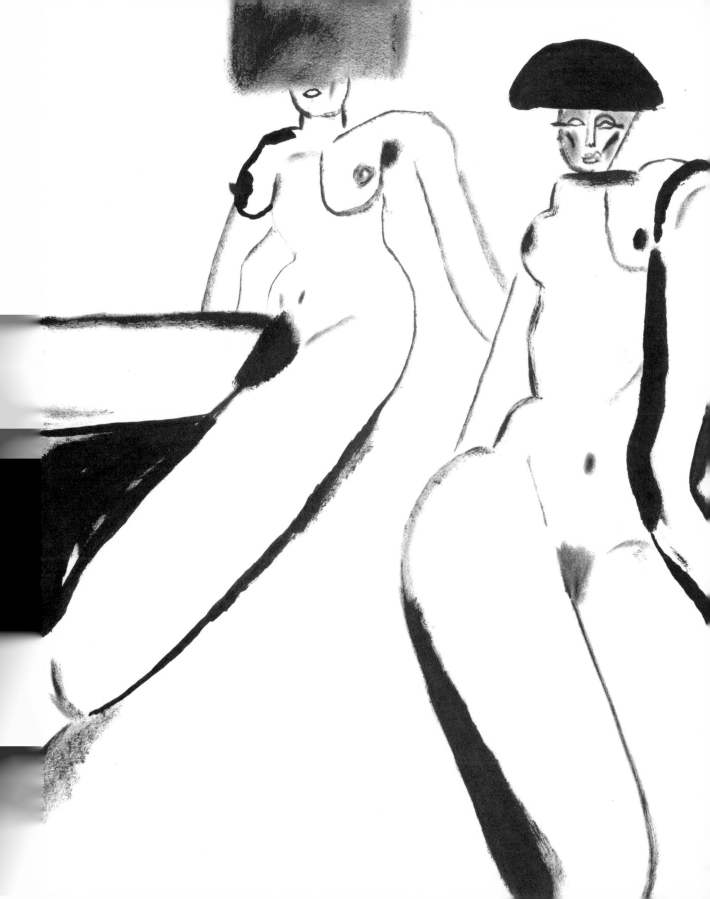

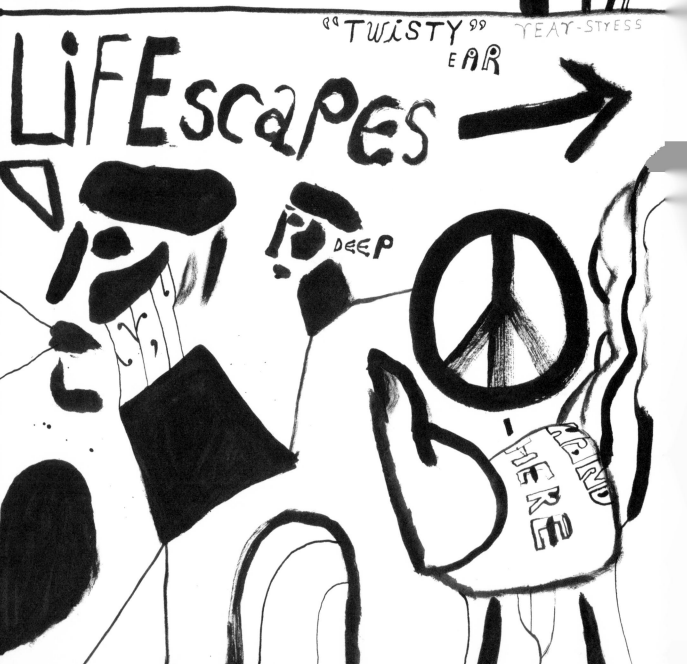

σ'
αγαπώ
αληθινά
Π'ΑΝΤΑ

'16

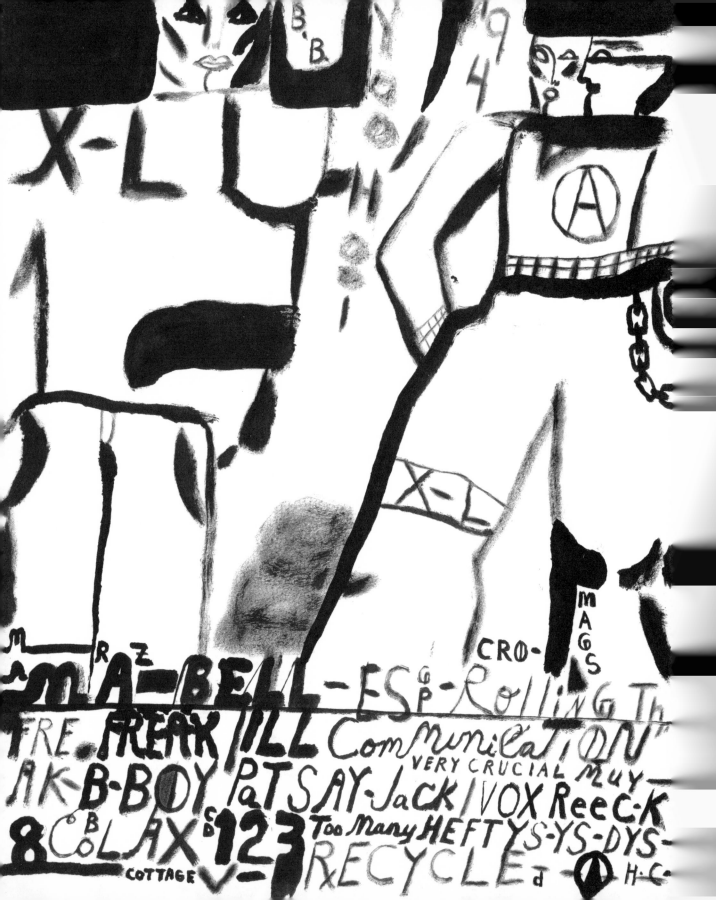

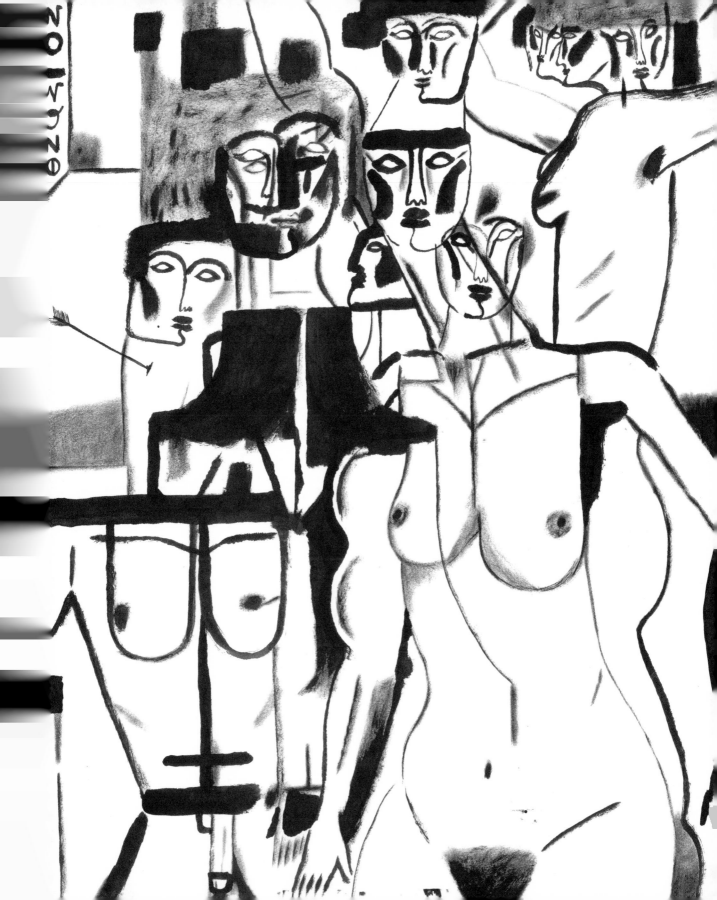

I've Seen Love in All Its Shapes

Young
Old
Wrinkled
Smooth
Small breasts
Large breasts
Pill form
Drinkable
Fast
Long
Middle of the road
Toad
Frog
Princess
Homeless
adventures
misadventure
Hired
Fired
Strong
weak
Water
Sand
In
Out
Blue
Green
From the sky
From the earth
Opportunistic
Nurturing
But the shape of you
Tells all
Through the leaves
I've had you spotted
From the hills
To the valley
From castles
To a car

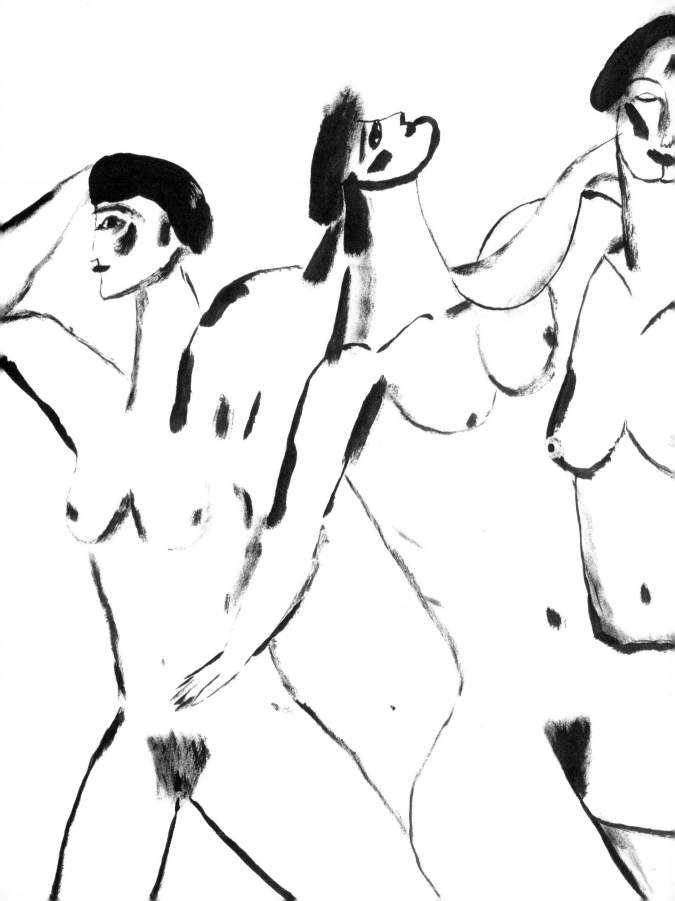

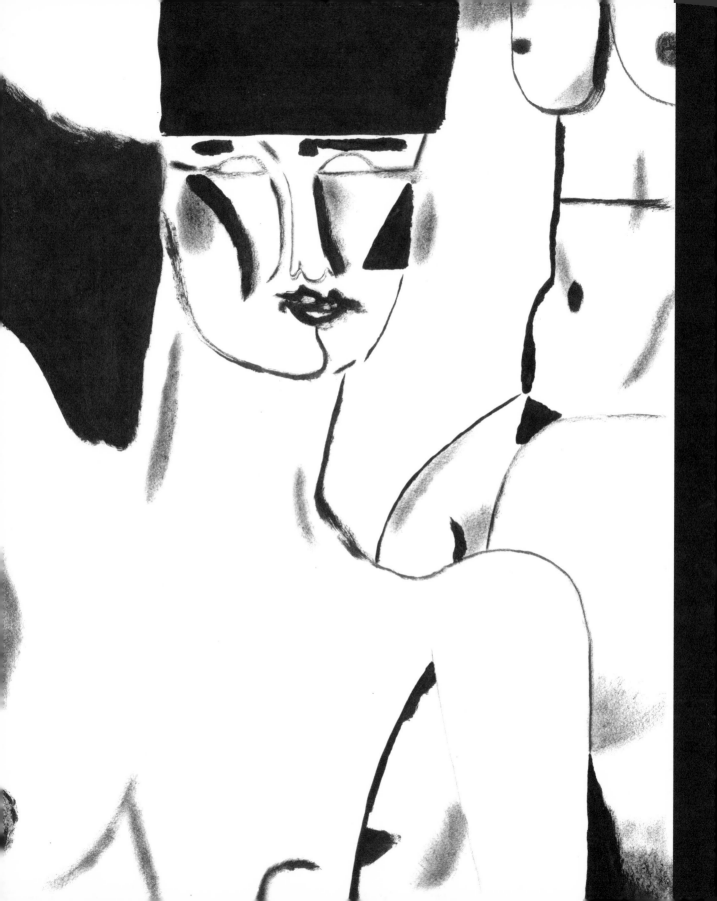

Lonely Only Lonely

Only hold me
Do not fold me
I cannot fit
When I sit
Alone in a room
Dust my broom
Shoulder the weight
I'm not thinking straight
Lonely only
Fire below me
I want to change my world
Have a daughter with curls
Name her Saxophone
And always be home
I'm dust in your broom
A swimming costume
Dispose the old rudder
Throw me in the gutter
I live with the rats
All present and past
I'm the world's biggest noose
I'm the golden-egg goose
your kiss, heaven sent
body benevolent
All I want is your hand
If you feel, understand
That I'm lonely for you
Only lonely for you

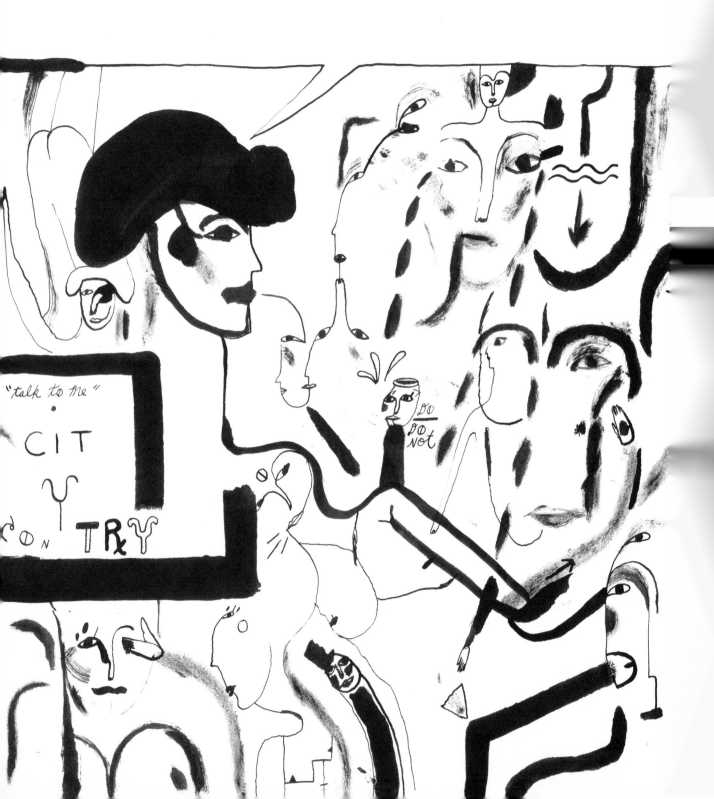

AN APOLOGY TO POISON. And NO CROW EATING. To have LOVED & To Be Continued. SILK SMOOTH ROOF
A LAUGH TO CRY & here'f YR horoscope Note. I i'm TRYING The Good TIME ~ And NAVIGATE TWISTS —
HOPE ~ [OF Love.] EYE SCAR

WIND

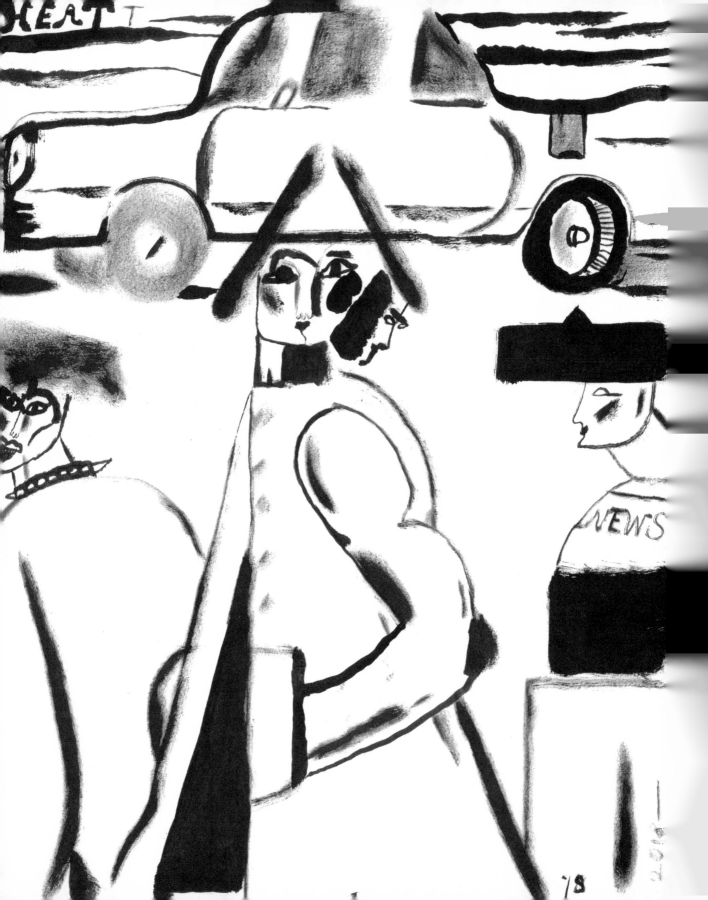

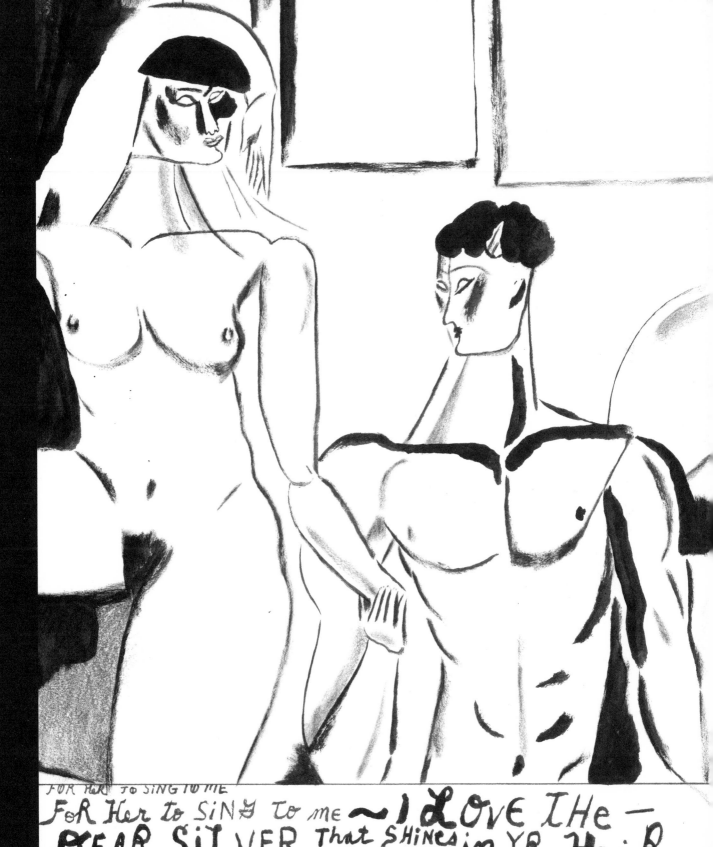

FOR HER TO SING TO ME
FOR HER to SING to me ~ I LOVE THE —
DEAR SILVER, That SHINES in YR HAIR
JUNE-24-2019

La La La-LA-La-Ba-Ba-BB

▮▮▮ ▮▮▮

º Frills FREE/CURR.me (i) +
Can't THiNK ᵣₑₙₜₗᵧ₋◍ Rₓᵤ
THE WiNK
the bReath! I KN◍-GL◍W
Don'T LEaVE don't G◍
Give me myself-"i"
(AAStronomIcaL
muse. NeW/n◍W →
RefiLL/NOT Spell
Rₓ
i can TELL-GET
◍PEN-NEW

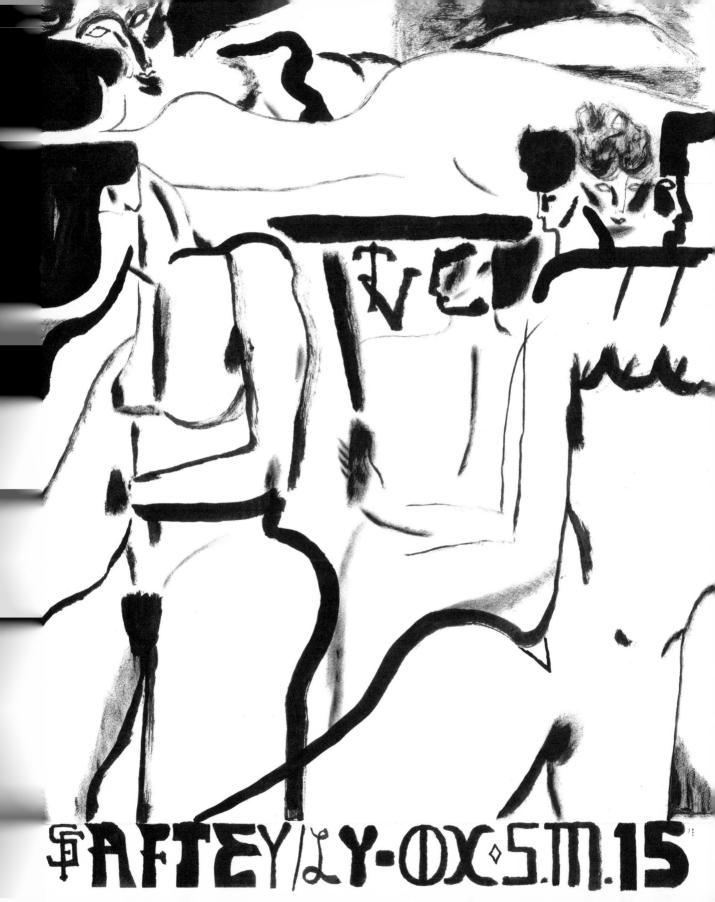

A Pair of Ducks

———

Drugs / To be good, to be bad. It's a pair a ducks. This sentence is a lie.
Let the God Almighty create a giant stone, which he is not capable of
 lifting. Talk to other apes, and chimp out.
Let the air breathe.
Let it out and relay. Sitting looking around like a cheeky cheekbone.
You may try, but do not judge the mental. Yes, the greedy man gives
 his cash with sorrow.
However, he doesn't have the cash with sorrow, so he gives what he
 doesn't have.
Oscar Wilde said: "I can resist everything except temptation."

A Price, For ?

———

The few things
that feel real.
i do not know what is down,
or what is up.
*

Saved: i wes Saved. waiter you say say nothing. OPTion. Control Galatic milk + The fairness OF THE Wind; it have fallen FoR You — SEA — The End (of Story) is nothing without you See. A state to cross-Let if The Whisper Ho- Let it snow - as if The Center of The World infinity Cast a lament 'O me Be good To SomeBodY & will I

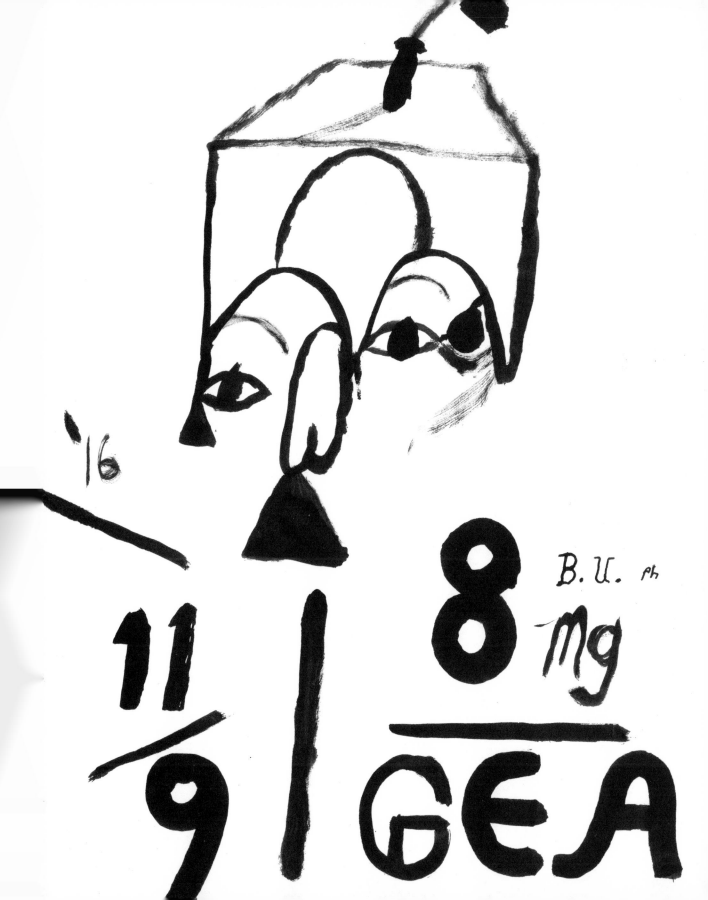

Afraid of What It's Worth

——————

I'm afraid for what it's worth
Insects under the earth
Look into your eyes
and get under
not to hide / wants their time / and pray like prey

I'm locked in a small plastic cage
If the toxic fume will kill
starvation gets its thrill
I'm afraid for what it's worth
I'm afraid to do the twist in the light
it's what time allows
maybe i will come around

I'm afraid to kiss the lips
of a wooden statue
gone missing in the mist
Underneath the hand and skin
I see a real-life baby girl
i see a fire extinguish fire just for the addict
-ed stage
I see a straight hair
missing a curl
i feel a pressure squeeze and neurotic release
I'm just afraid of what it's worth, now / I see my empty walk no thrill
I've seen a candle break in half
and survive that way
i love you all

Ventriloquist gone missing in the mist
Underneath the hand and skin
I see a real-life baby girl
I see a straight hair missing curl
I see my empty walk no thrill
Raven-dressed eagle perched
I'm just afraid of what it's worth

I've seen a candle break in half
and live two ways
I can pull the wick to last
I love you all
Only nice will cry
Why me, why not the other guy
Desperate roads
And The gods moan
And I'll be eating out of yr hand
Don't blame me if I bite you man

And you told me
I'm the clown expressing mirth
I'm afraid of what it's worth

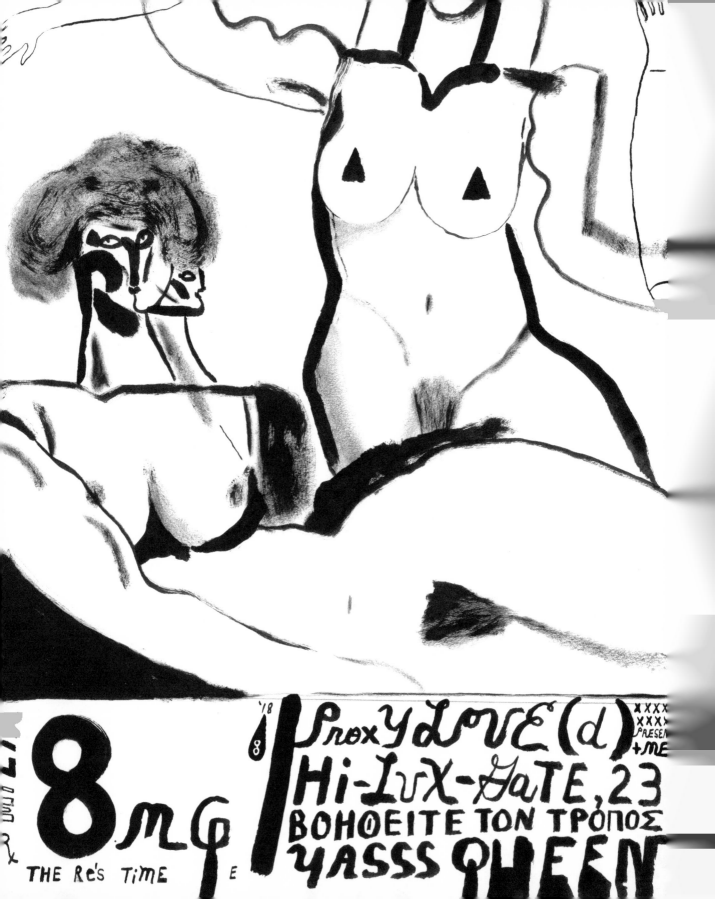

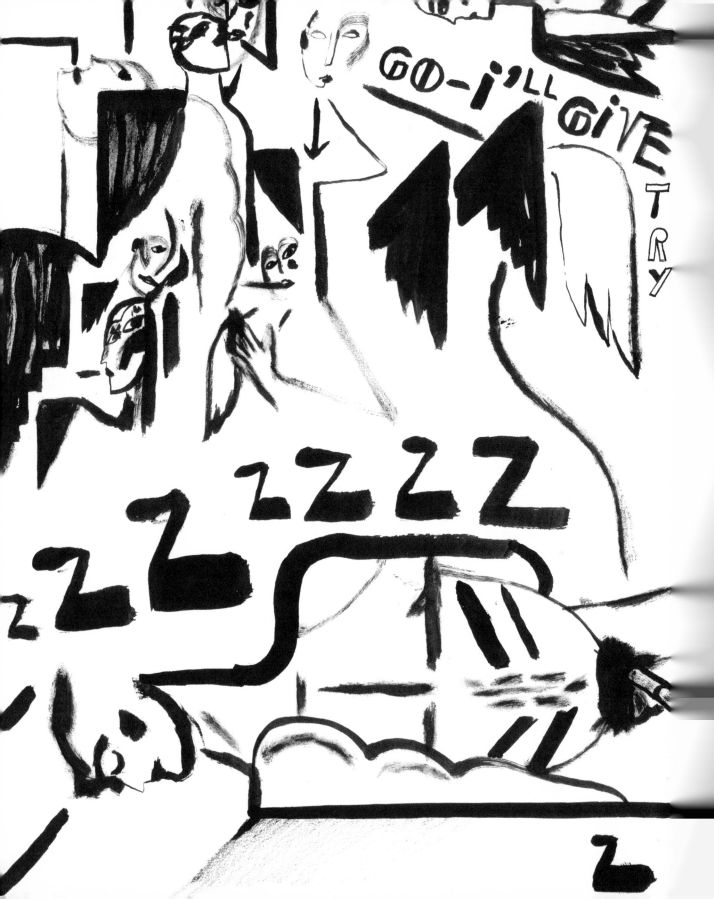

GO-i'll GIVE TRY

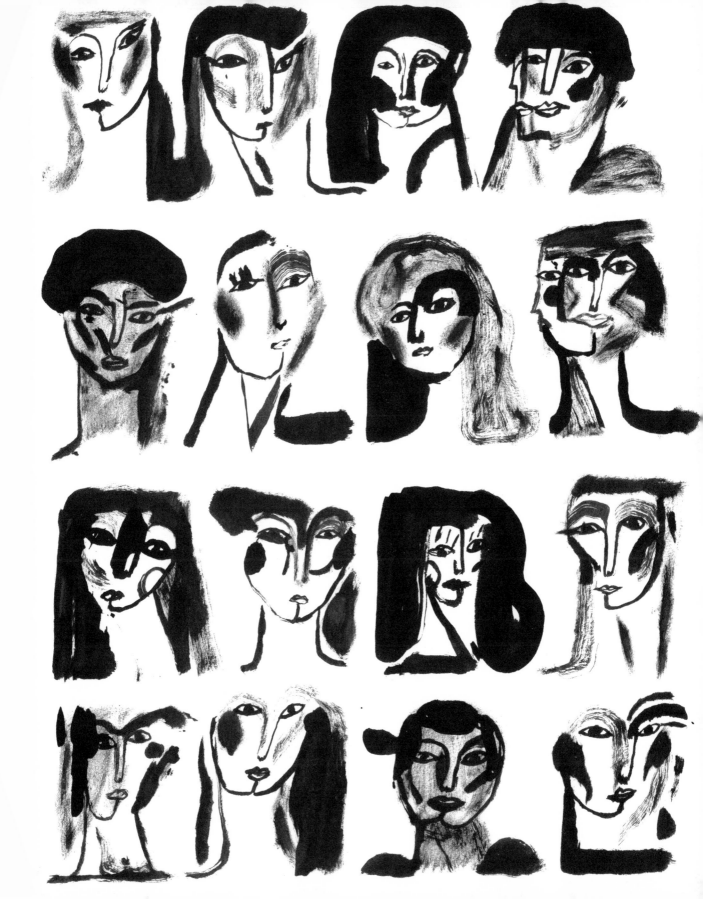

Depression

HOUR: Good
HOUR: Bad
HOUR: Good
HOUR: numb
HOUR: bad
HOUR: good
HOUR: Bad
HOUR: bad
HOUR: bad
HOUR: good
HOUR: bad
HOUR: good
HOUR: bad
HOUR: numb
HOUR: bad
HOUR: good
HOUR: good
HOUR: bad
HOUR: good
HOUR: good
HOUR: good
HOUR: good
HOUR: good
HOUR: bad

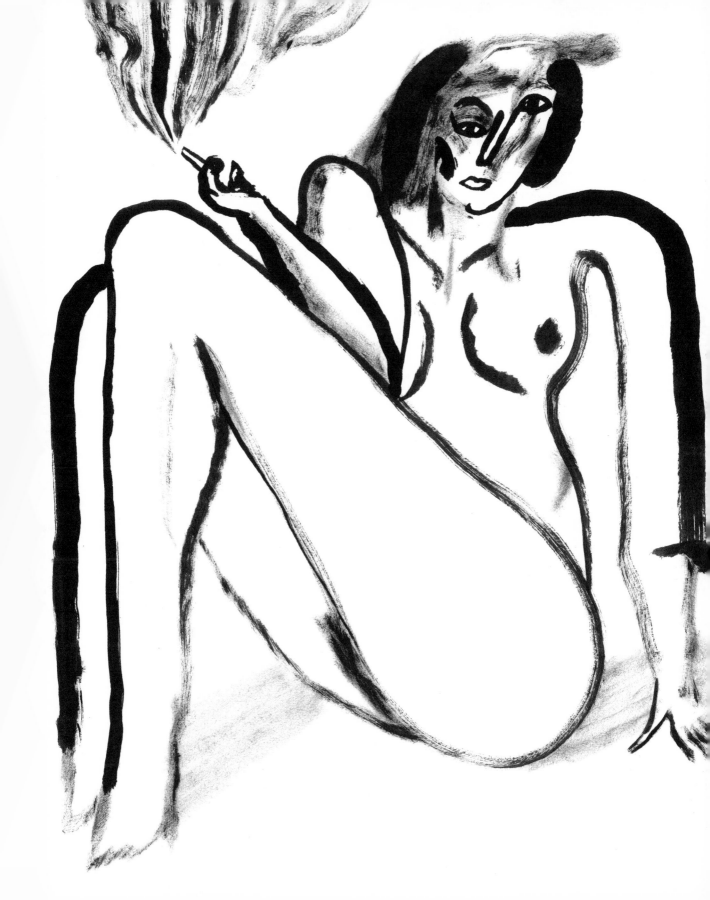

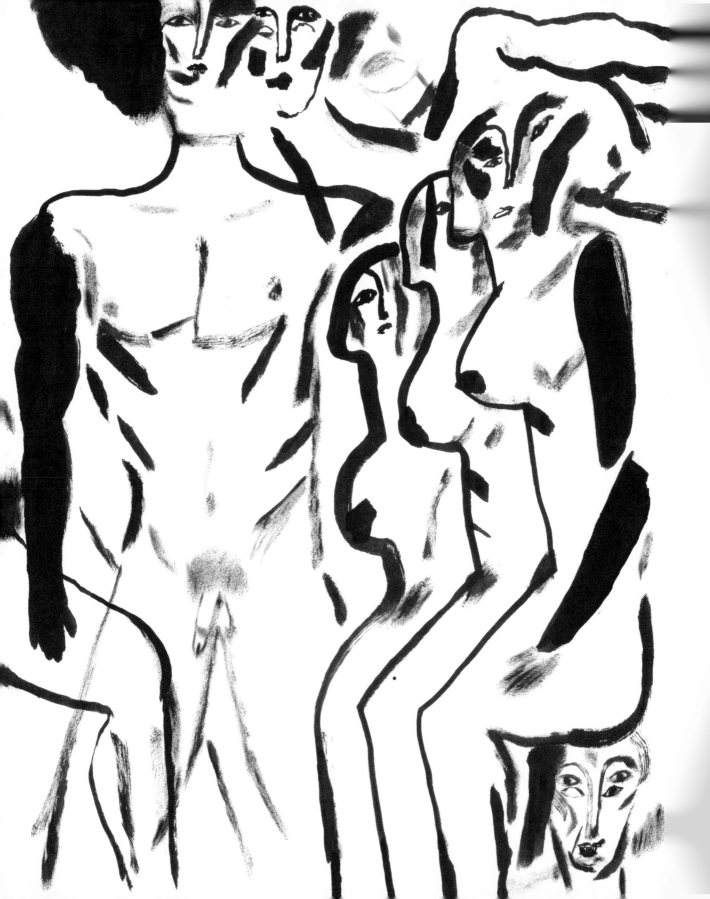

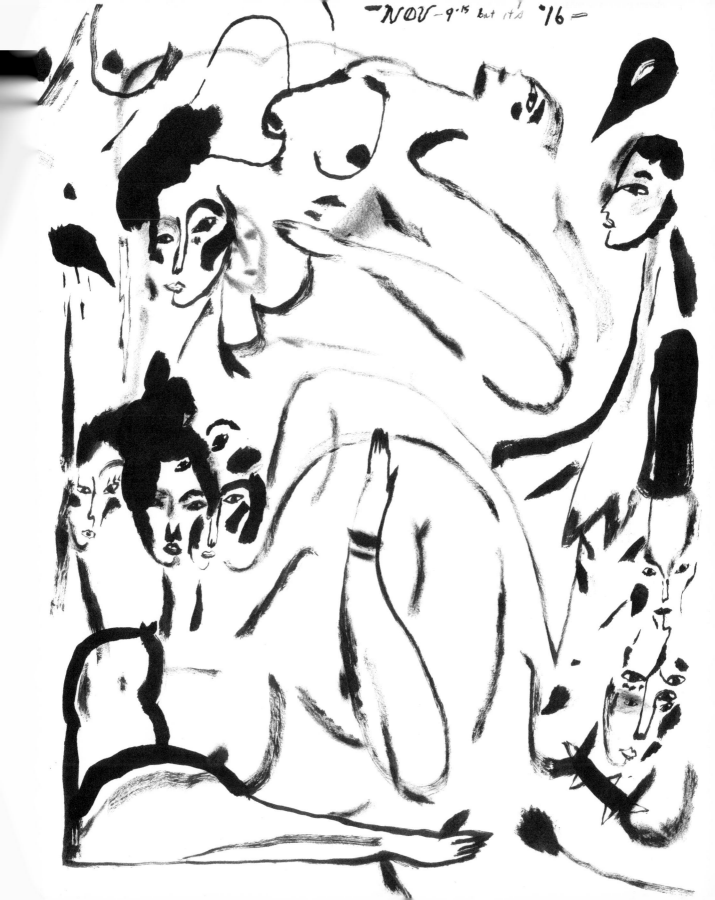

NOV – 9·15 but it's '16

6 A.M.

It's 6 a.m.
Do you know where
Your eyes are?
They are warm
under blankets
Of flesh
Hiding from Santa, and devils
Dreams, are a car
But you are not driving
You're looking out the window
Seeing the sights
Nodding out
Seeing sights again
The Ajax is under the sink
You'll blink
Be careful how you use
Your eyes
They may surprise
Someone
And you have become
Such a dream to me

It's Hard to Believe There's Something Wrong in Those Nice Little Phones

i can see it, i see it all
don't make me into an idiot
don't make me howl at the moon
turn werewolf.
I'm Dracula, goddamn it.
I'm refined, and know what i like
and,
that myth about garlic is false
i got sick to my stomach one night
eating too much garlic bread
hearing stories of you with him
i had to excuse myself
and throw up in the restroom sink.

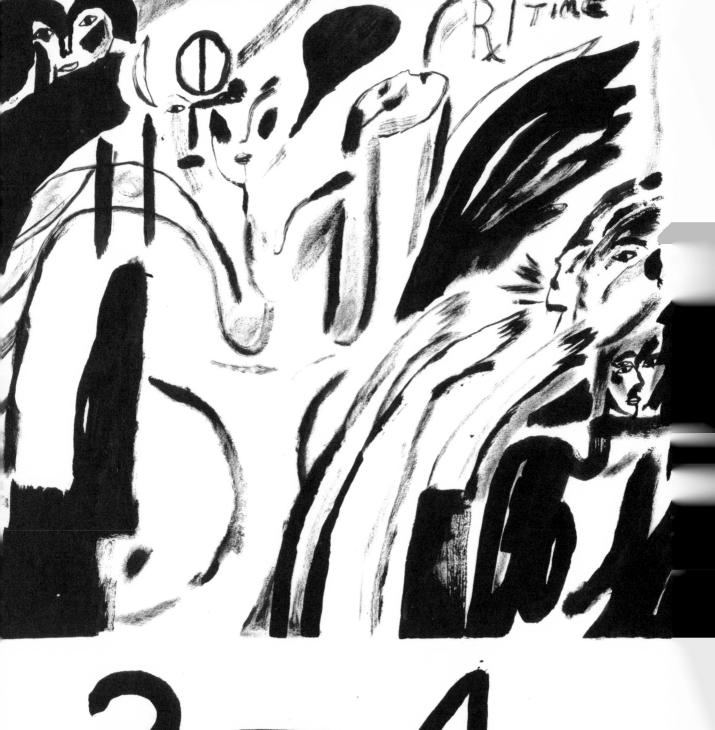

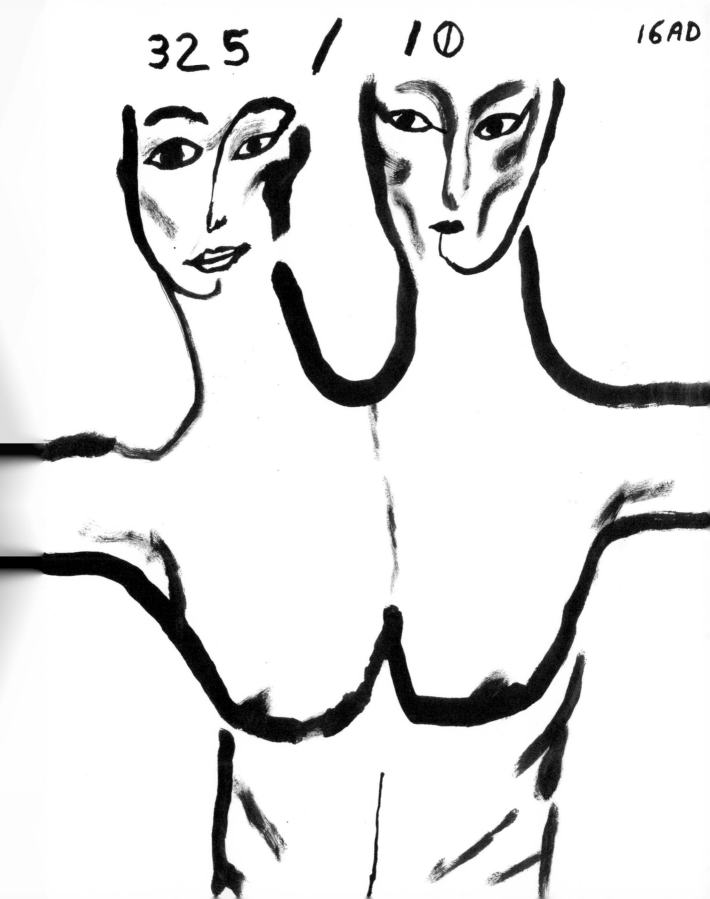

Prisoner's Dilemma

Squeezing me out
Breadcrumbs to my end
Ripping me off
My heart
is my entire body
It's all for you
If you want that new romance smell,
Then own it
go buy it
Tell me the truth
or give me back
Beat me to it
We,
Two burglars in the night
Jewel thieves
made out with many diamonds
Getting the jump on one another
Prisoner's dilemma
good cop / bad cop
what have we done?
You play the getaway
you took a truck
Take your luck
And be gone
You have fixed the match
I have no say
They are all in on it with you
(i am)
On the out
In an outside world
(you, now)
In an ocean filled with fish
You sail
With a strong arm and spear
You could fish forever

till you grew too old
to get in the boat
For me,
In the piss pond
mosquitoes bite every inch of my ass
serenity venom
my brain, and spirit
I have not
The strength
Or ability
Look,
I'm in the washer
and soon
will
Be
in the dryer
Just tell me you still love me
And I'll stay pressed,
and possessed,
And full of fish
And wearing jewels
and all of our diamonds

N-D-J-
F-/S.m.

BeLL'S
RiNG

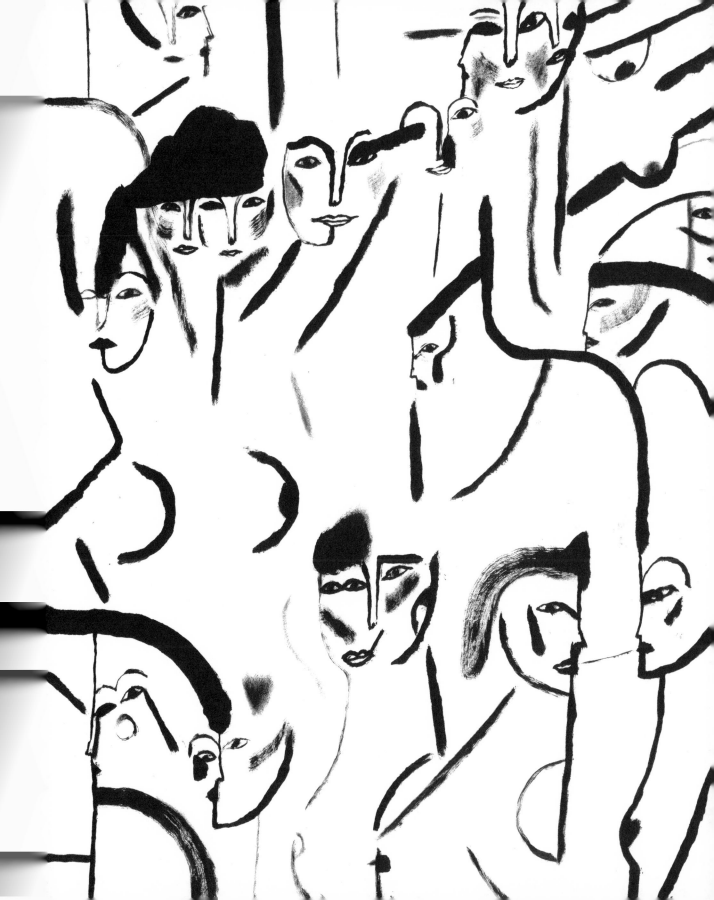

True love goes full tilt
Unstoppable kismet
Never to forget

I think of my death
A quiet now, nothing left
Somewhere a bird sings

Could I take my own?
You took me by a surprise
Without you, I fade

Mesmerizing girl
Is there a place in heaven,
That we can sit down ?

We had a time there
Blue skies and cats at bird play
Naked swimming hole

My hammer hits once
I could never take two loves
Fate like Greek god blood

Why can the oil paint,
Capture abstract visual
From a brain to a brain ?

The jailhouse phone call
The unsolved case of your love
Fingers cannot touch

Take me very slow
Sexy way you hold me down
Take time, in our time

Broke, tilled, thawed, planted,
Plucked, raised, burned and broke again
The heart corrects soul

Getting high
Suspension of disbelief
Which one, lie or truth ?

During a hard time
Believe in any spirit
You want, it's your soul

I hate your hot hell
Your punishment has killed me
I need a kind soul

Let down? Let it go
Every wave is different
Some carry, some not

Basic instinct, film
Was shot in San Francisco
Picasso paintings

How ya doing cock?
You alright? Welcome back here
I'll see you around

She never mentions,
My name, or how much I mean
To her, if I do

Spilling in the streets
Lovers, tricksters, heroes and
Villains, parts of plot

The goddess of love
Powerless to help a fate
Adonis, the boar

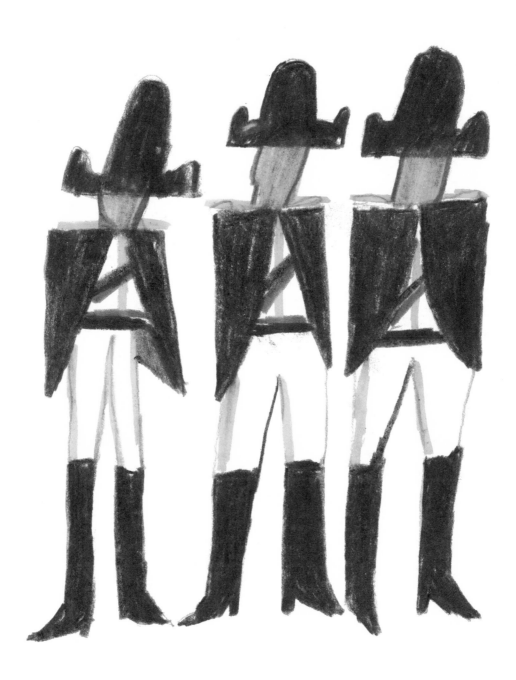

valium®

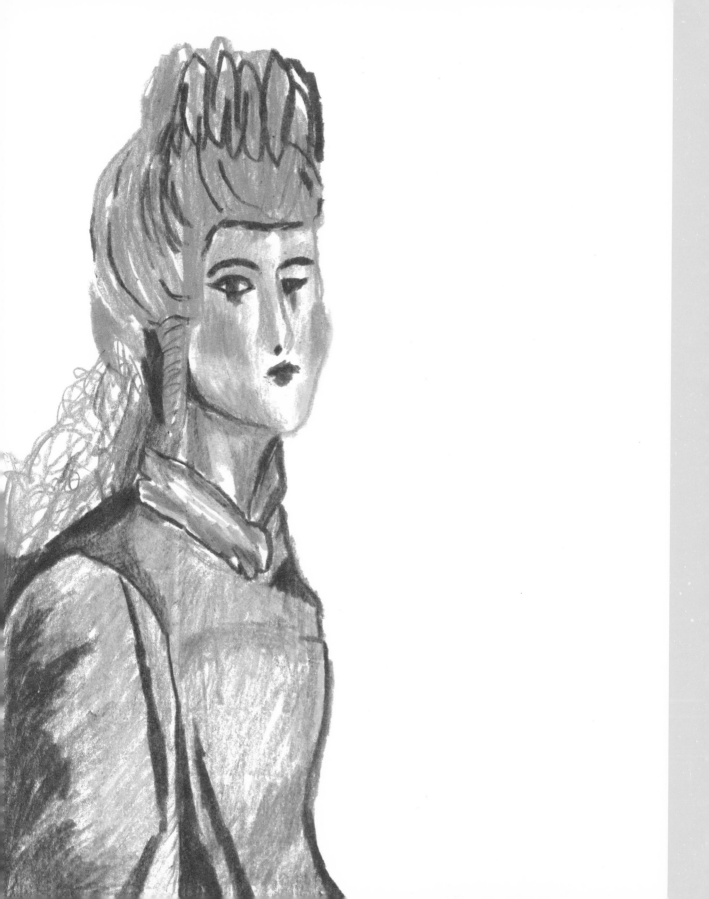

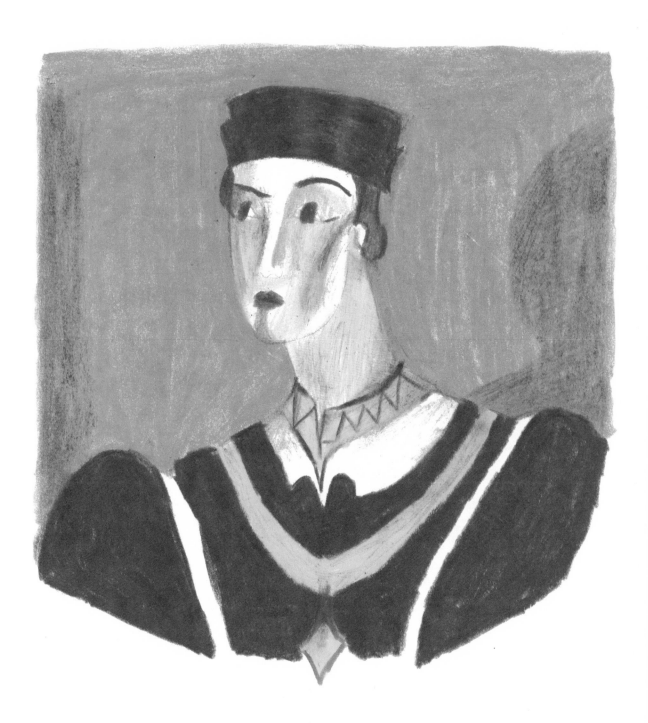

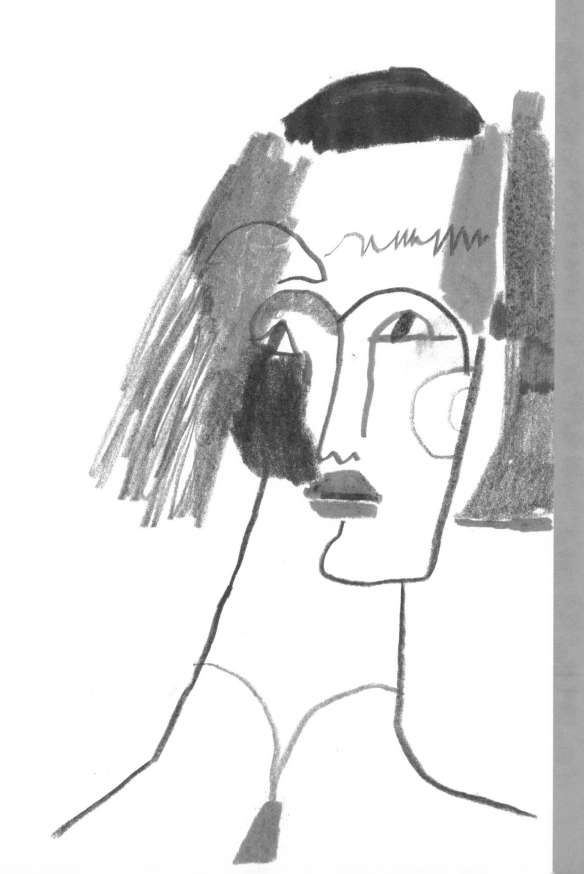

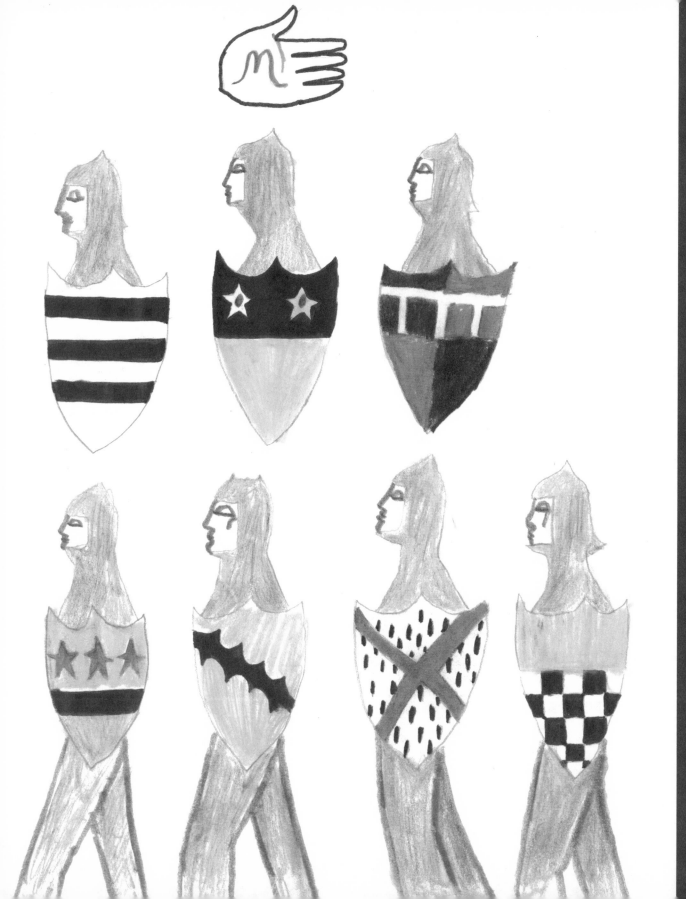

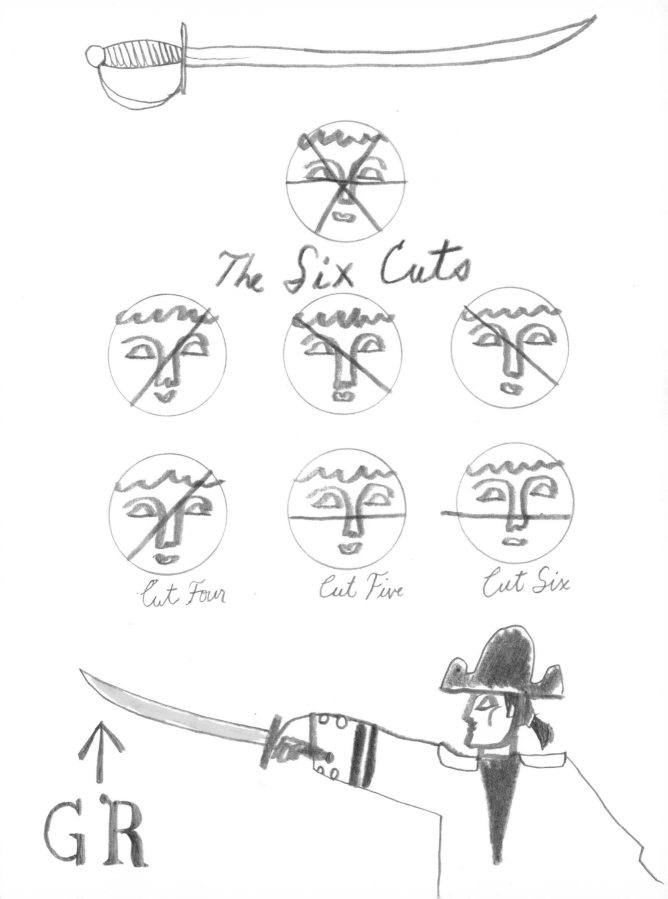

The Six Cuts

Cut Four Cut Five Cut Six

G R

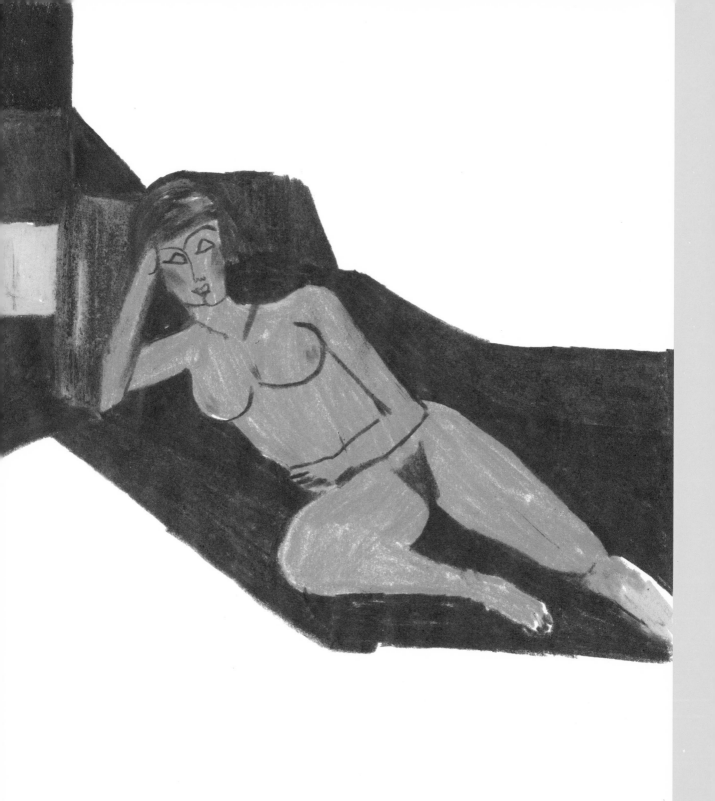

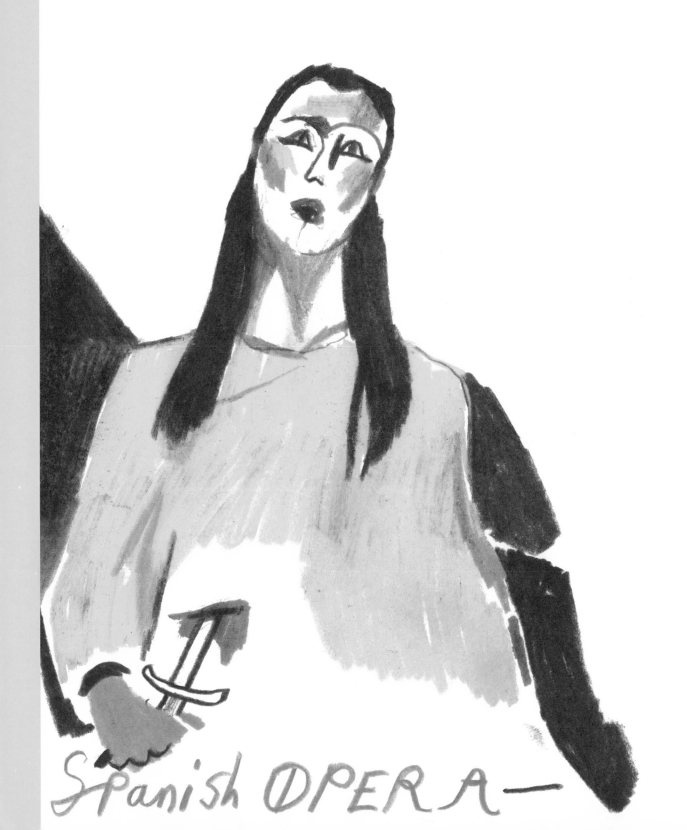

Spanish OPERA—

CT's
Chair /+ The housegest

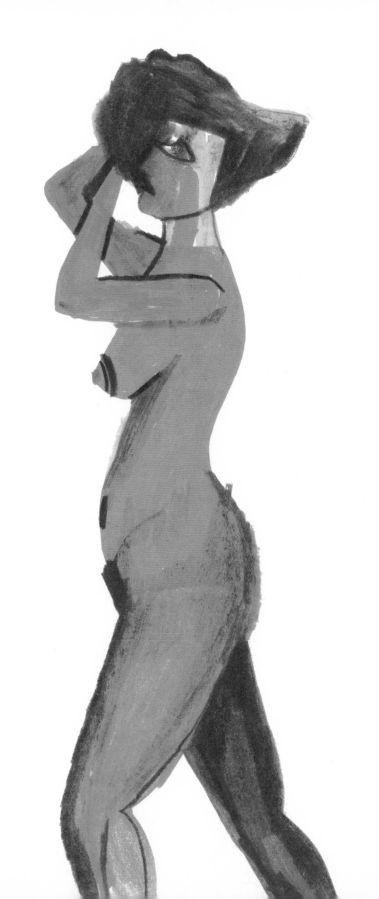

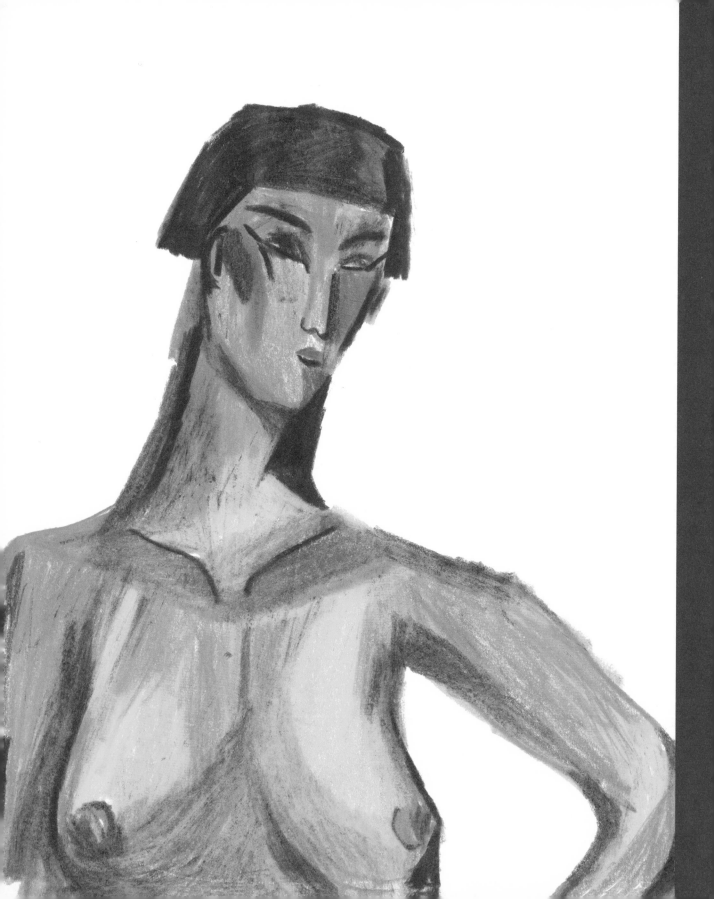

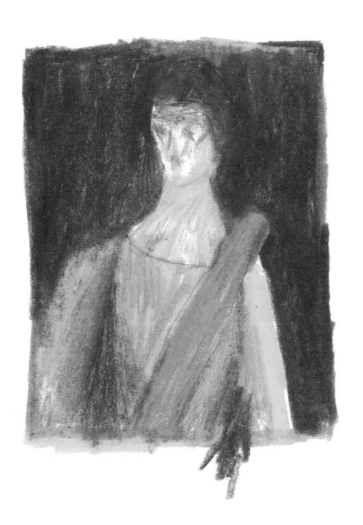

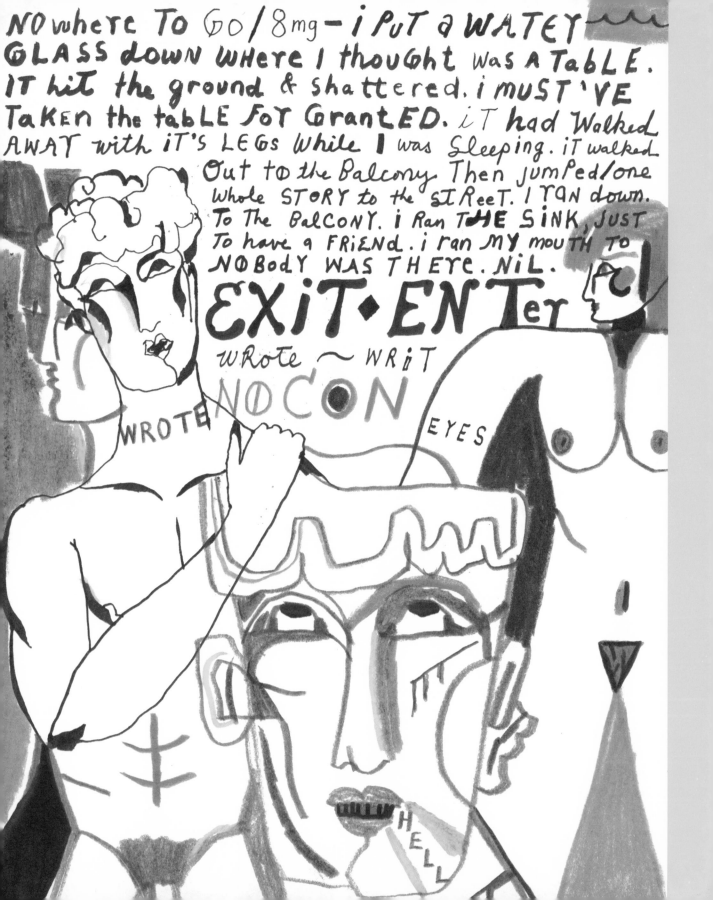

NOwhere TO Go / 8mg - i PuT a WATEY
GLASS down WHere I thought was A TabLE.
IT hit the ground & Shattered. i MUST'VE
Taken the tabLE FoY GrantED. iT had Walked
AWAY with iT'S LEGs While I was Sleeping. iT walked
Out to the Balcony Then jumPed/one
Whole STORY to the STReeT. I YaN down.
To The BalCONY. i Ran THE SiNK, JUST
To have a FRIEND . i ran MY mouTH TO
NOBodY WAS THEYe . NiL .
EXiT • ENTer
WRoTe ~ WRiT
NOCON
WROTE
EYES
HELL

you are Angry — OK

& it's My Pain, it's OK

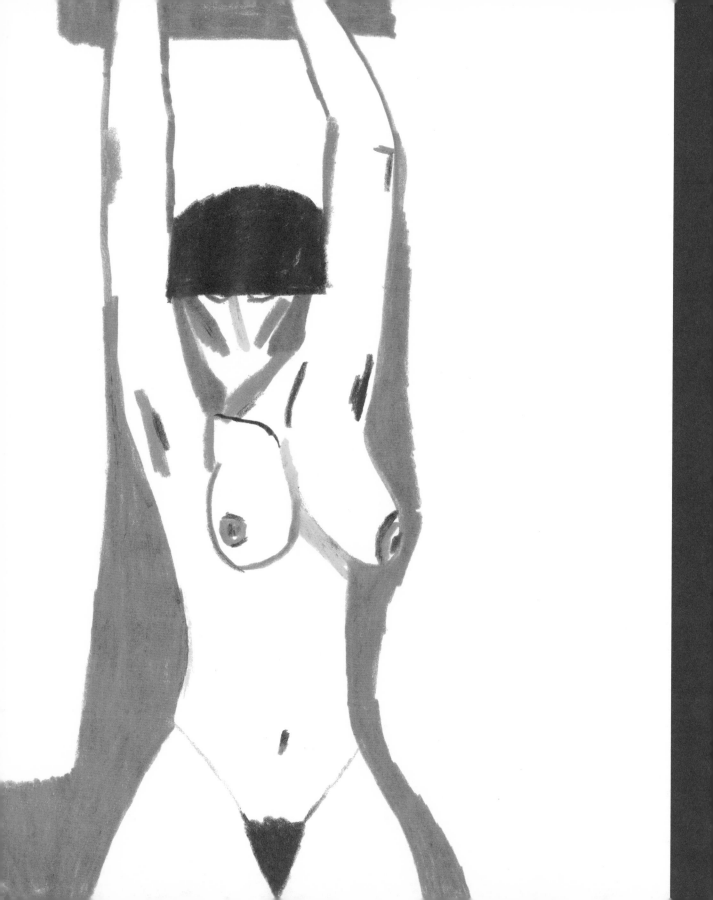

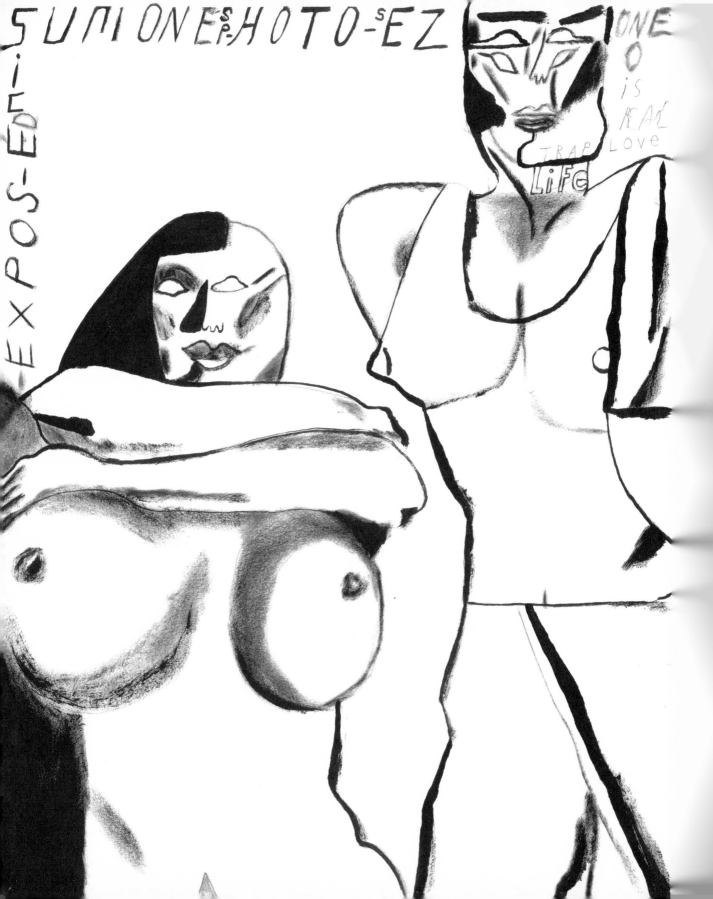

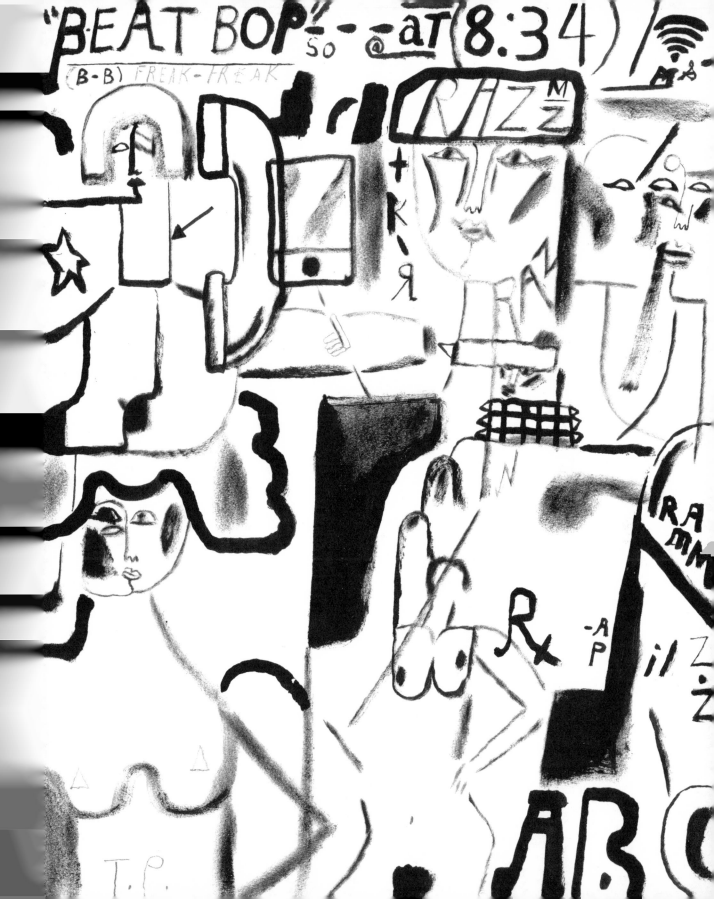

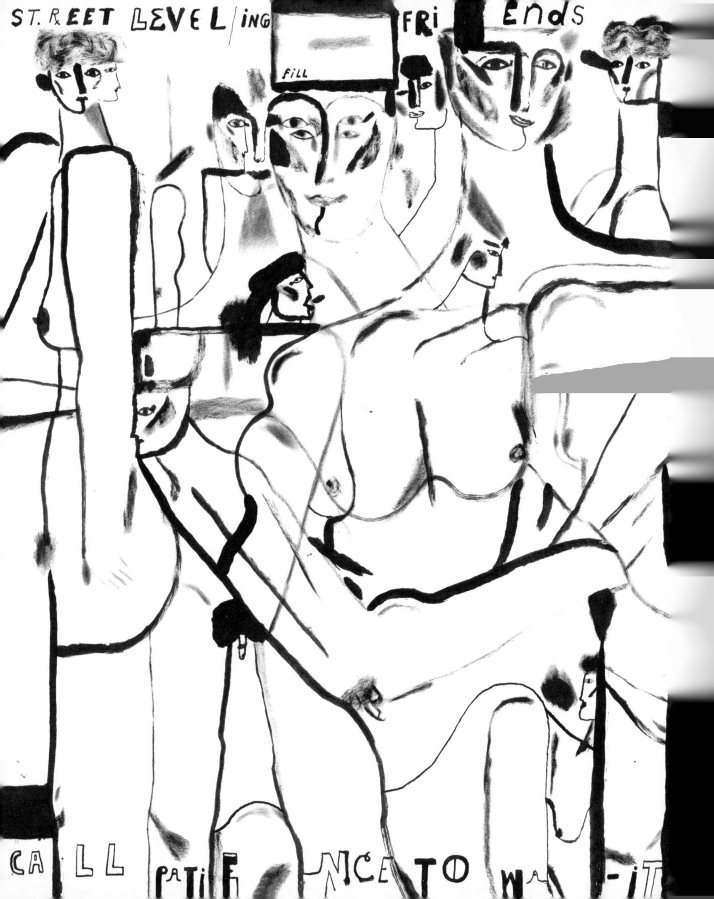

STREET LEVEL/ing FRIEnds

fill

CALL PATIF NCE TO WA -IT

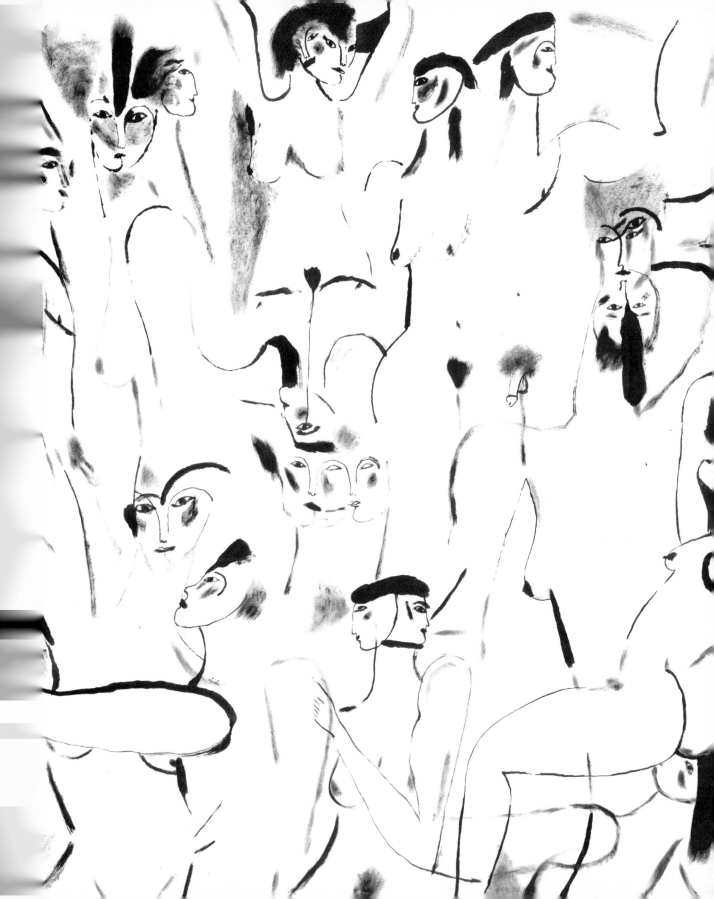

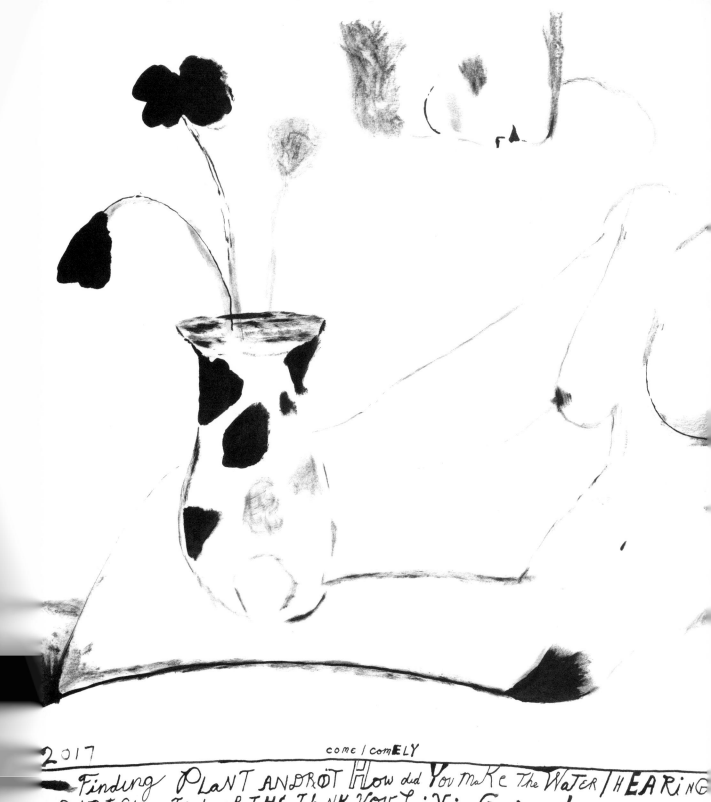

2017

come / comELY

Finding PLANT AND ROT How did You maKe The WATER | HEARING
Did Not Stay TO heAR THE ThaNK YOU LiVinG + Taste LiKE WATER

FEB. iF i WAste myself. Waste NOT. "ON US"?

Dear Friend

How do you love me?
with my words and heart, you take good care
you hired a doctor to check up on me
you have always been there
for me
after hours days and years
But,
i have done the unspeakable
i have lied and betrayed you
i need a mask to even look at you
i live in the gutter
speak to you through the drain
i am dirty and smelly
i wear flies like clothing
my dark green hair is matted and sticky
i rent a room in a garbage can
my only companion a drunk pink worm
i have bent the truth for too long
my tongue is a rusty silver dagger
& i am sorry
i weld my visceral mind
i lose control
i am a nameless error
and you, . . . are beautiful
for good or for ill
we have come to this intersection
where i reveal my lack
even though, i am a caring one
that walks a bird
every week
i love and rule by love
OH, CARVE THE WIND WITH YOUR SWORD!
i practice, and i don't match up
i'm alone with my thoughts
an Easter basket of fire

what is my life?
what have i done?
I've cut off my nose
despite YOUR face
I've hacked my own soul
i've set an alarm, of police patrol
I'm sorry but she is the Rum Tum Tugger
it's not my fault completely
it's oppositional, tidy . . . neatly
with an hour of rehearsal
i never could fail
squeeze me clean
i'll come to you
with all that you need,
friend

CARAMELIZED BE EVERY THING TO-TO SOME One I.S.F. '17

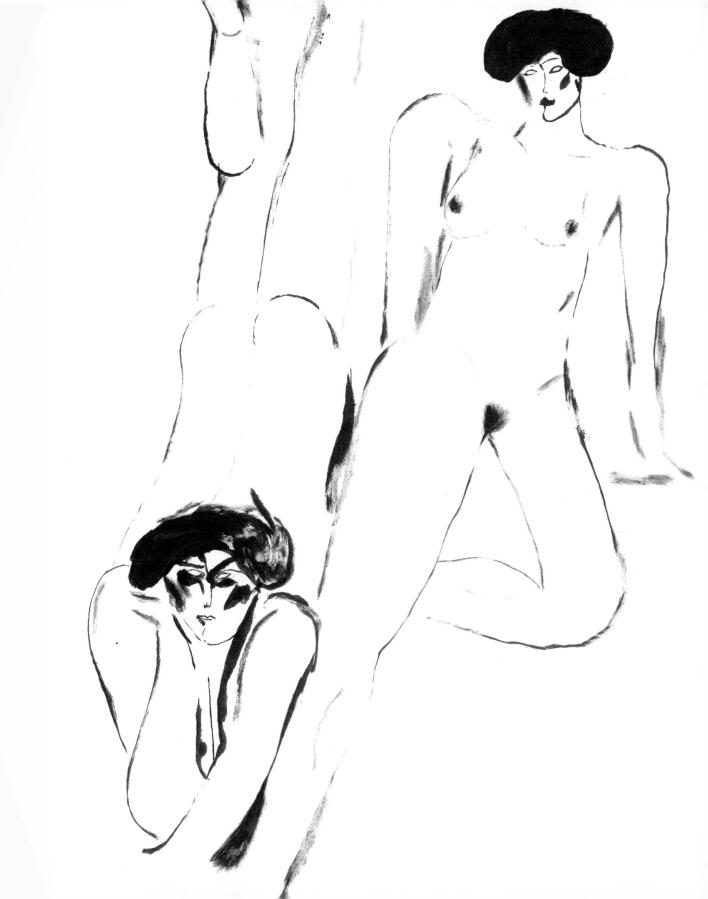

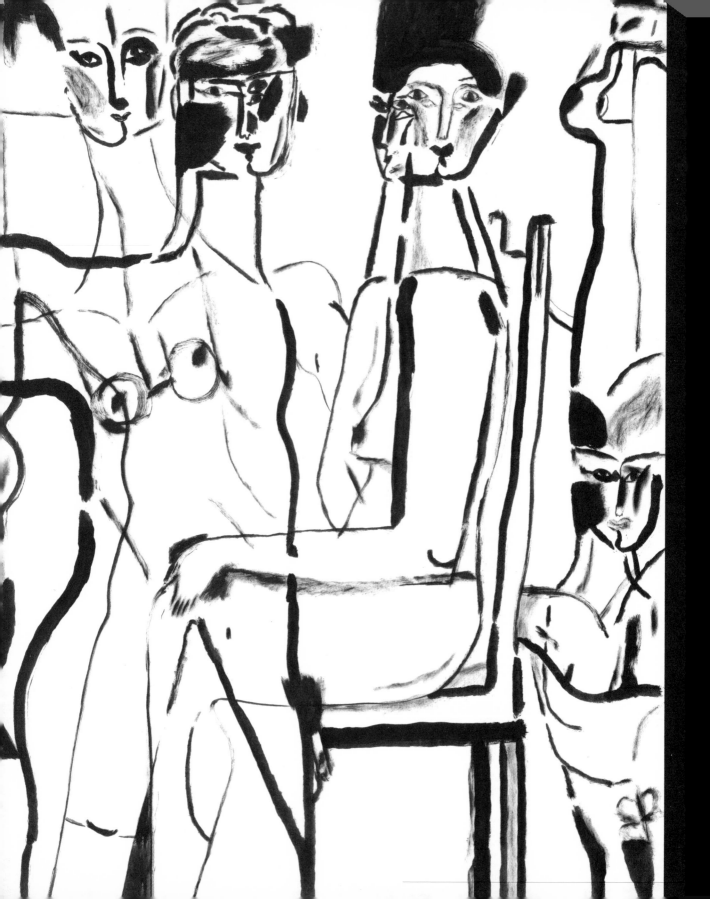

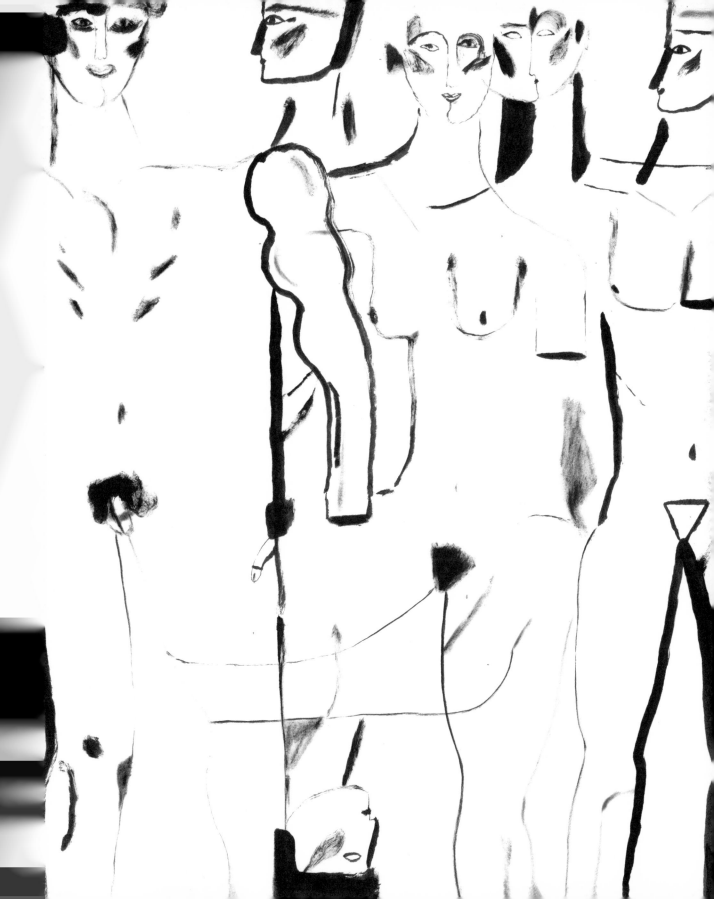

Fucking Sex

Dry pants lay fermented
wet skin in a blender
get you off
apologize for sucking
come fucking is a coward who kills Goliath
can you imagine?
the last note played is the strongest
the last string pulling on the heart is the tightest
i could bronze sex with you
i could sing its praises
even after the last crow dies
i'd eat my crow
I'm eating crow
alone, and to no one
with salt & pep boys
my appetite for you is only
my love for you is holy
slit my face when you leave
why don't you
pink breeze in the tree
lightly leaving
fuck you forever
and ever
a wheel of lovemaking
that never stops
coconut lube
in an engine
keeps working, we work
a bond or a chain
linked—
infinity bodies
it takes two, to find one

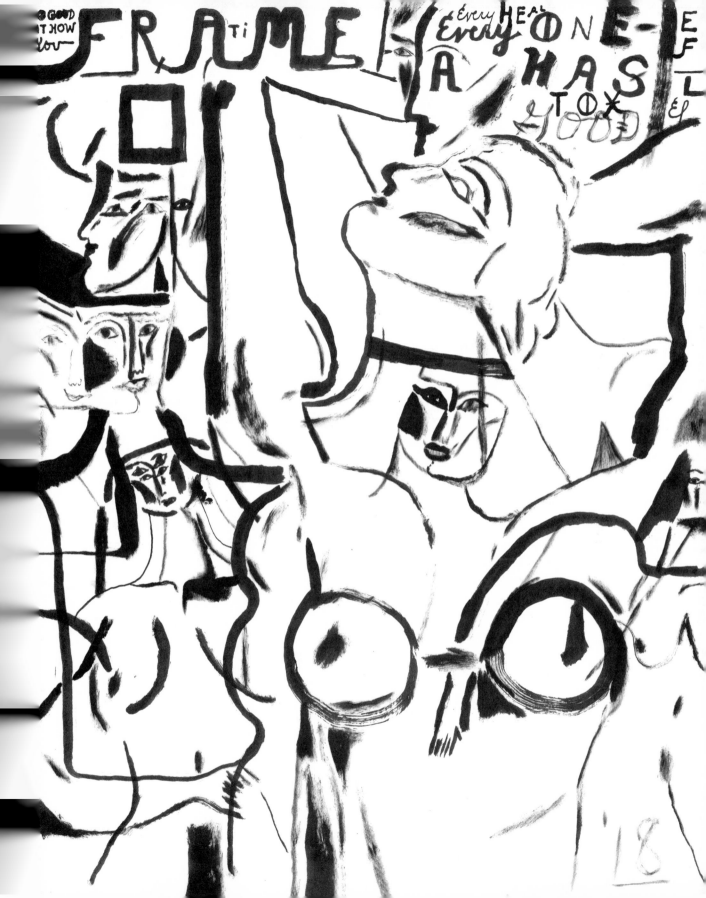

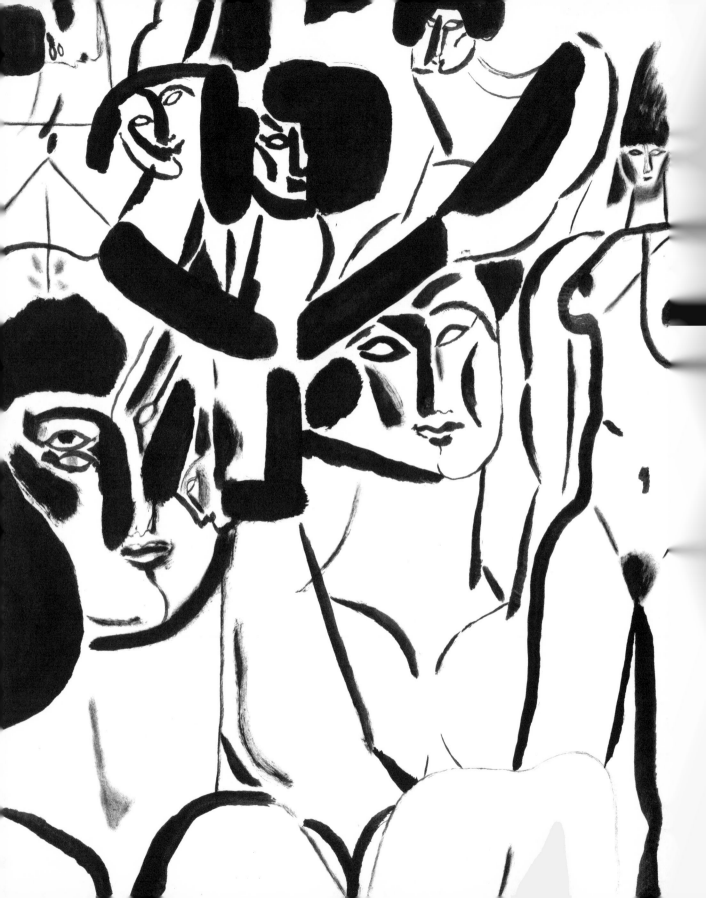

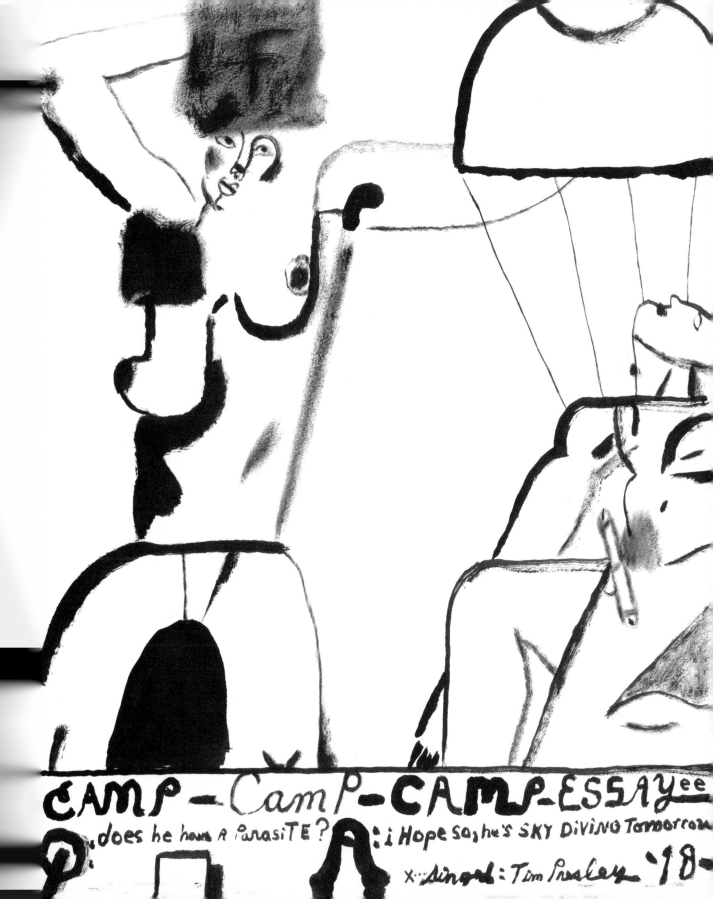

CAMP — CamP — CAMP — ESSAYee

Q.does he have a parasiTE? A.i Hope so, he's SKY DiViNG Tomorrow

x...Singed : Tim Presley '18

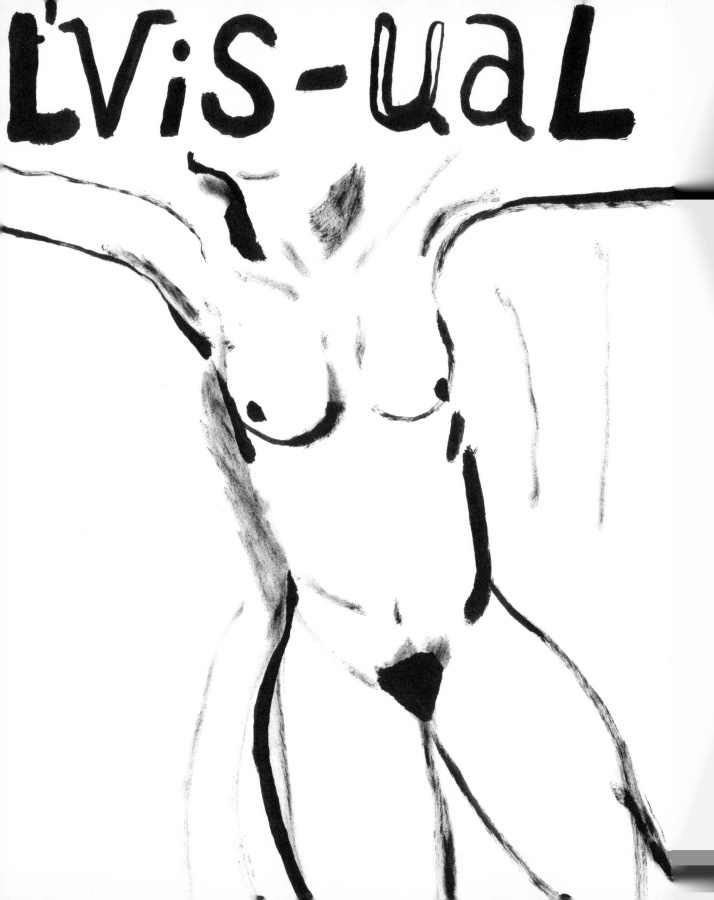

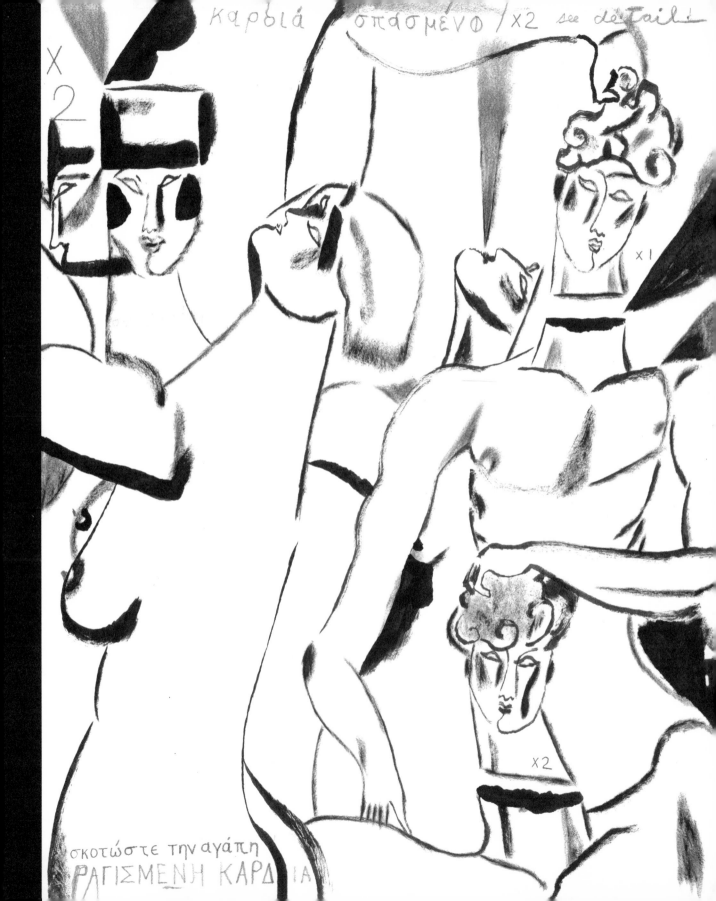

We Don't Need Much

Don't put roses
on the bed
Don't put them
on the ground
Don't scatter them
as romantic trail
It's a waste of flower
All the power lifting,
Living
We don't need much do we?
Give me snow and ashes
Or a scorpion with a restaurant
I can't eat
When I'm stung
I've lived in Phoenix twice
Once a snake, once a cactus
Now a wild flower
And I'm laughing
in the fire
All my clothes have left the building
We don't need much
do we?
The heart is red
The heart is in the bed
All that love
could start a war
It's the idiot in love's restaurant
It's the scorpion on the phone
It's your body in the tub
I hold the purse
with gloves, lips & spit
I need eyes and brain to touch
We don't need much do we?

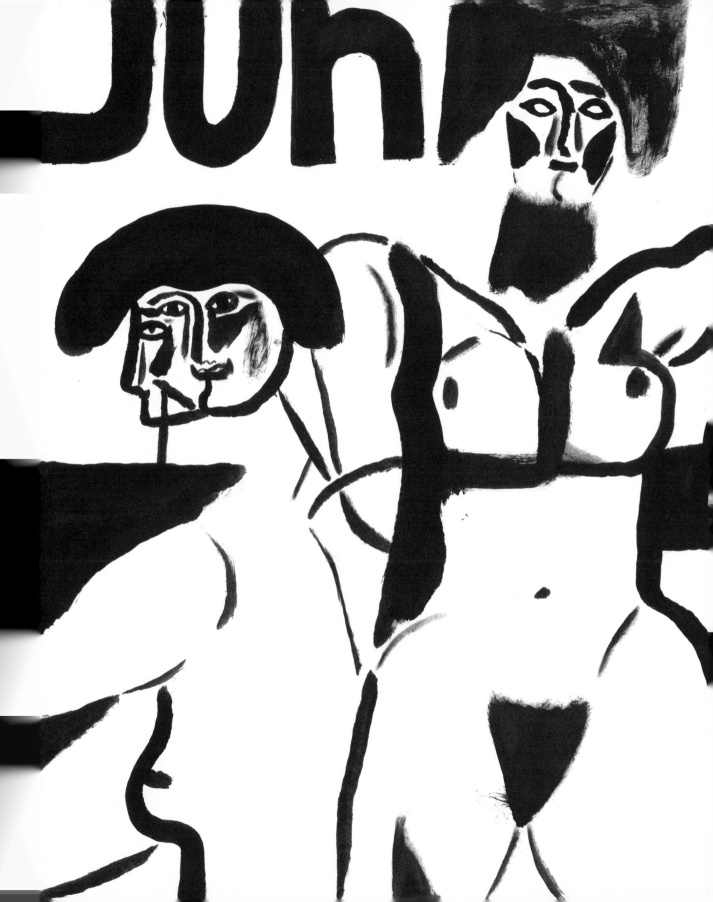

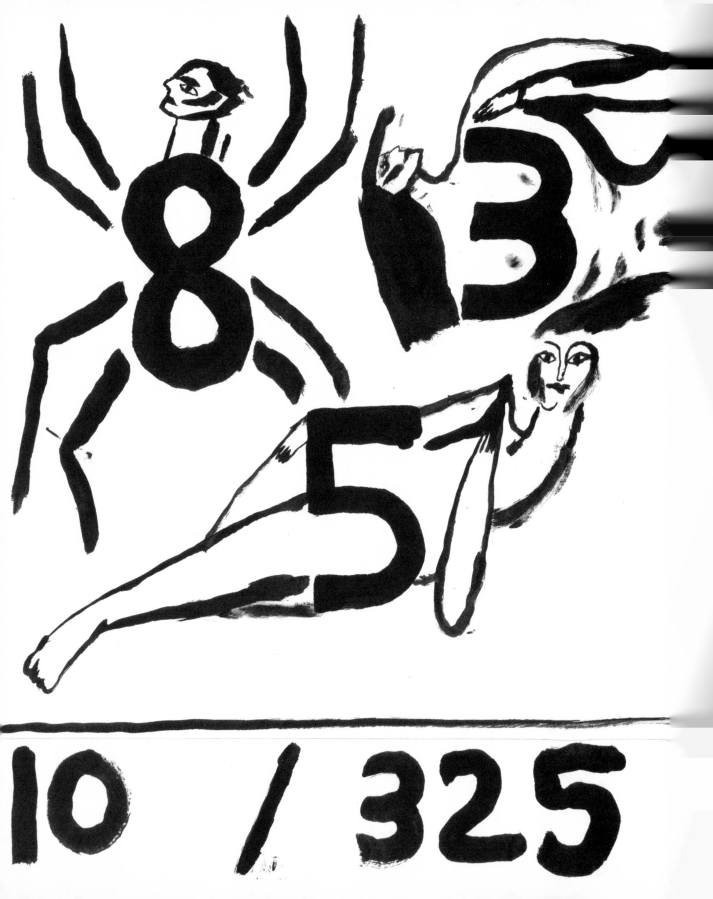

Razor Blade in His Mouth

He had a razor blade in his mouth
He had a razor blade in his mouth
He had a razor blade in his mouth
He had a razor blade in his mouth
Super deli
Card declined
So hard
I could not find
A cigarette for the masses
A 1998 quarter from Kansas
Sell me your weak drug
Sell me your fake poison
Sell me the sperm of Poseidon
In the tough streets of prayer
That's a beautiful hat
I have $100
You know what it's for
Angels yelling: I never need more
I'm out of the game
And into the rain
I have an umbrella in my mouth
I have an umbrella in my mouth
I have an umbrella in my mouth
I have an umbrella in my mouth

AND MY HEART WAS COLD; BeCause OF THE FRESH STEEL ARMOR —
AROUND IT. WAS NOT ALWAYS TO BE, OR THIS WAY. THE FIT?
Steel OF Armor ~ June 2019 ~ MMXIX Banner/Concern 11 (2)

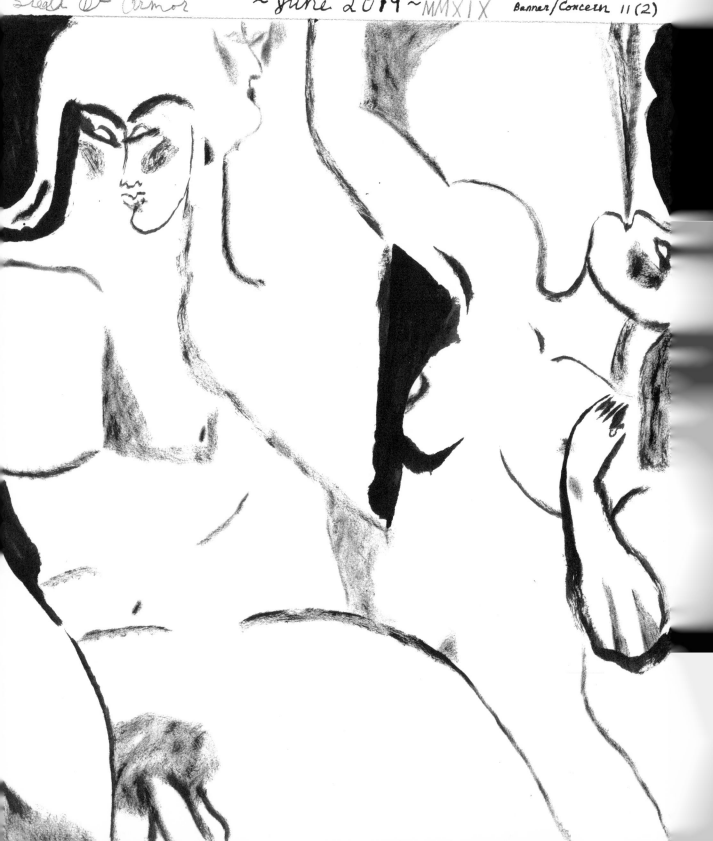

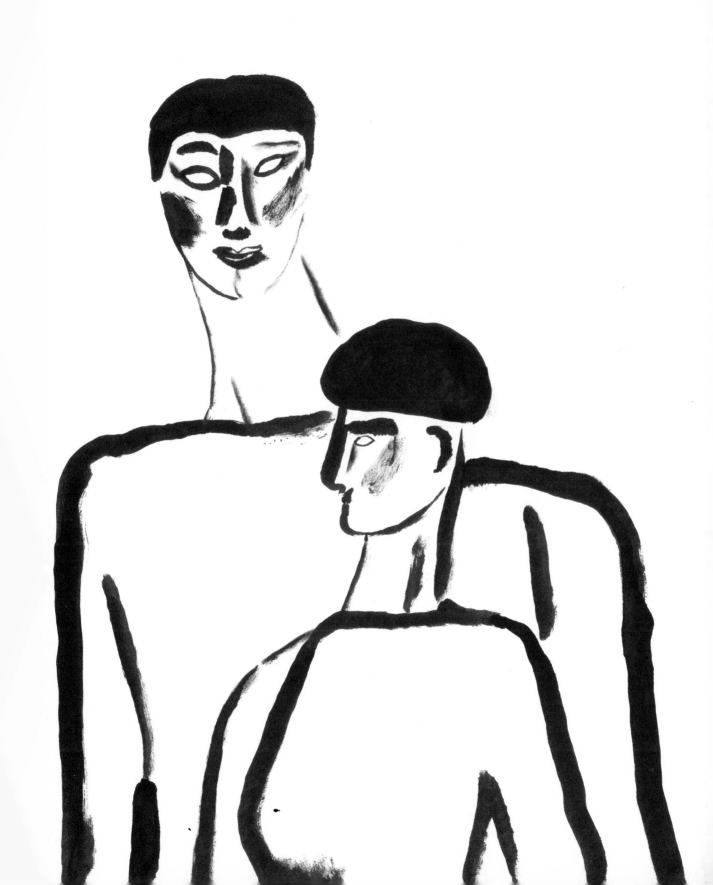

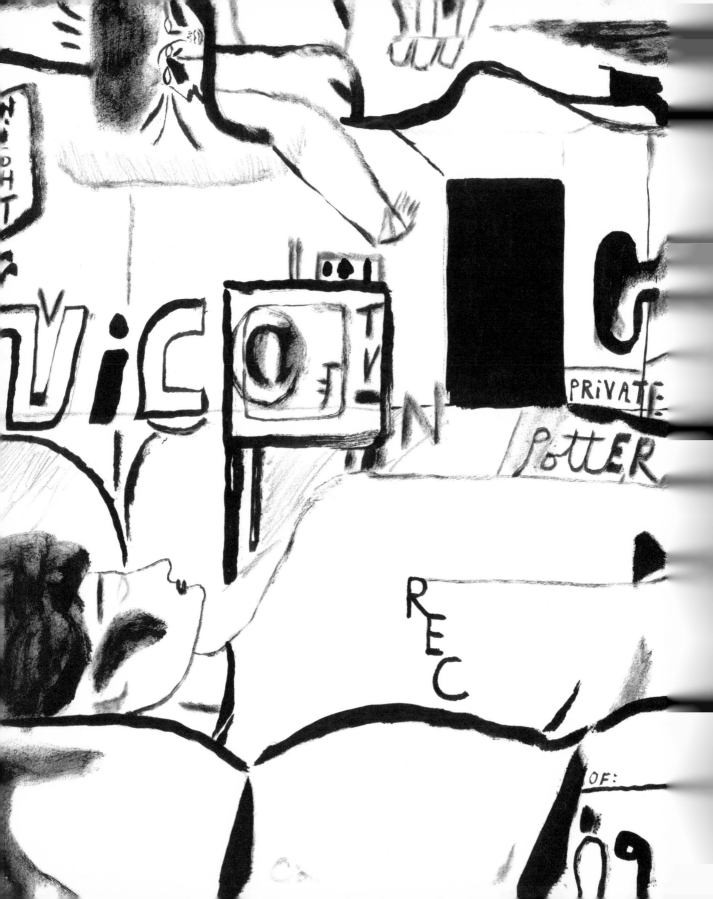

To an Enemy, Send Them Whiskey

send them vodka
send them all the things
a world gets lost on us
send them smiles
send them sex
send them everything they'll think next
here's a bullet
dipped in barley
there is no need to call me
here's a dress for your lady
here are tiny little shoes for your baby
send them food
send them flowers
send them anything at all
in your power
to the enemy within
to the devil below
there is sacrifice here to bestow

i'd send myself but this all is for me
i'm an angel, devil and man, all three

if you look for my face
in my old dirty place
it was you who left me to cower on knee
and to my enemy i send
this thought from my pen
i cannot pretend that i'm not writing to me

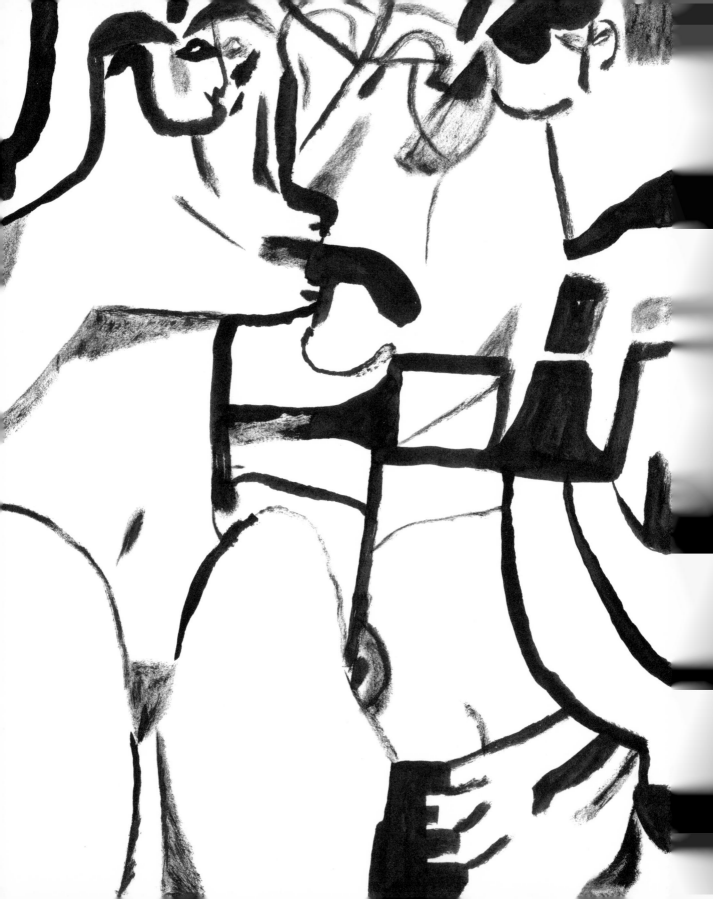

DANGER CHEER Despair JECT Cheer

JECT-ANG-PERA-ONDEN-CY-ORD-COM-RROW-hedX-FedEX

Ocean & Geneva

get out from under
the bag, the jar, the thumb, the needle
people snitch!
people gasp!
you can live like a dream
like no one's ever seen
like no one's ever been
you were a true badass
from Tennessee
needle hanging
from your arm
with a bottle, whiskey in the other
you could fuck up a skinhead
with the timbre of your diction
your drawl
your lips and teeth could turn into Rottweilers
your tombstone teeth
right below giant brown moon eyes
also,
you were a sweetheart
a gentle man
my looming thoughtful roommate
my cereal friend, serial breakfast
you can borrow anything you want
you can tell me about your lost love back home
in the south, back in Tennessee
how you love, how you miss her
you were born and bread and buttered there
for hours on end, i was your serial therapist
i was your friend
Marlboro Reds
the King and Cash
and Sham 69
don't cross this boy
oh hell nah

the boy from Tennessee
you were loved
your friends loved you
that one friend of yours,
she was sweet and charming
we used to fuck
when she wanted,
she'd come in my room at night
and want me
she knew what she wanted
we were all misfits
you'd smirk and smile about it the next day
we were all trying our best and second-best
you cried about your pain
affliction, and addiction
i understand it all sweet boy
it all caught up to you one night
you died in your bed,
in my shirt that you borrowed for the night
you said goodbye to me
did you know then?
that night, before you left us all?
did you know
wise ones . . . just know
it's spiritual
you know how much to rig
how much is too much poison
flash!
rigor mortis
but, almost peaceful
that morning
that morning comes back to me
as a silent play
called Ocean & Geneva

Today - ink

MAN-dES-PréS

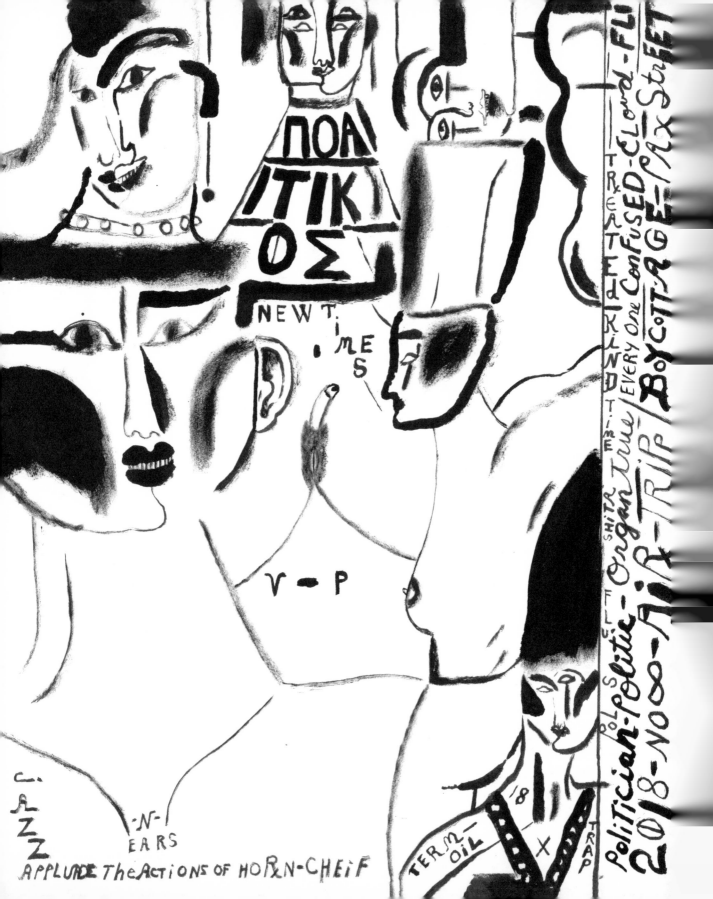

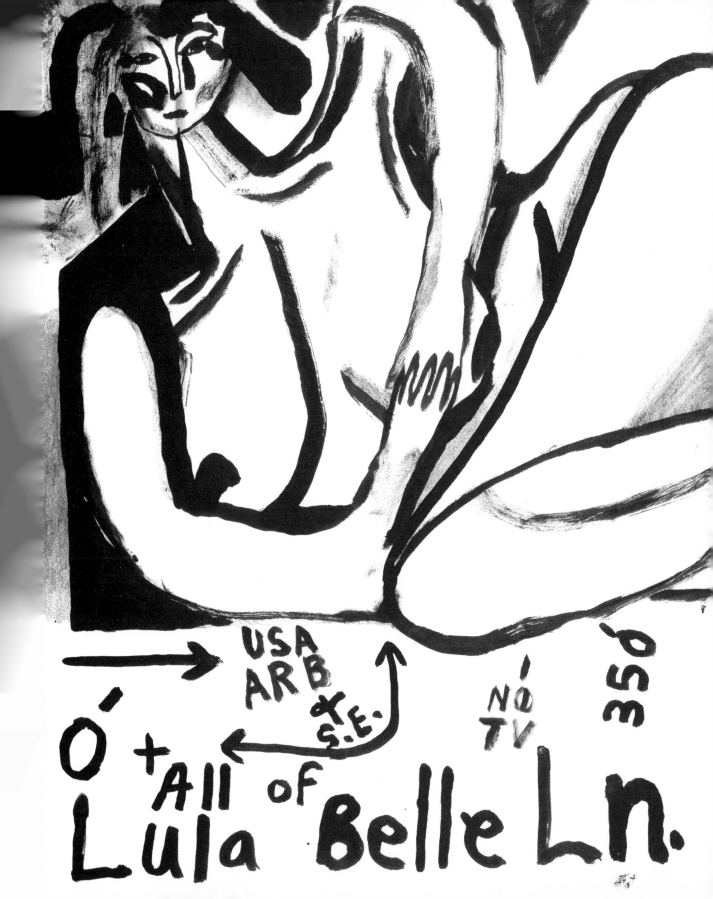

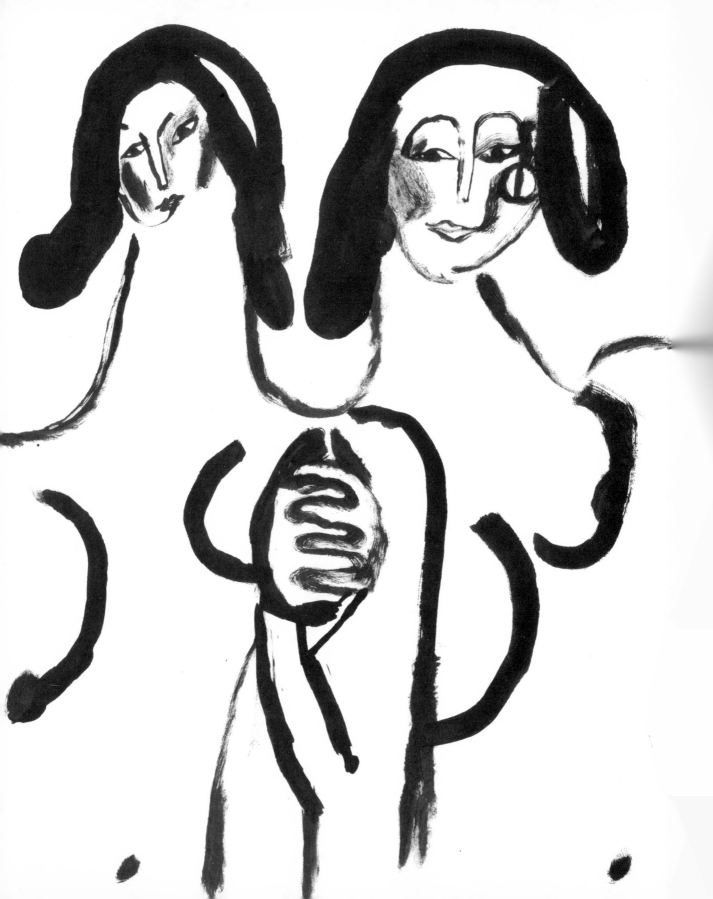

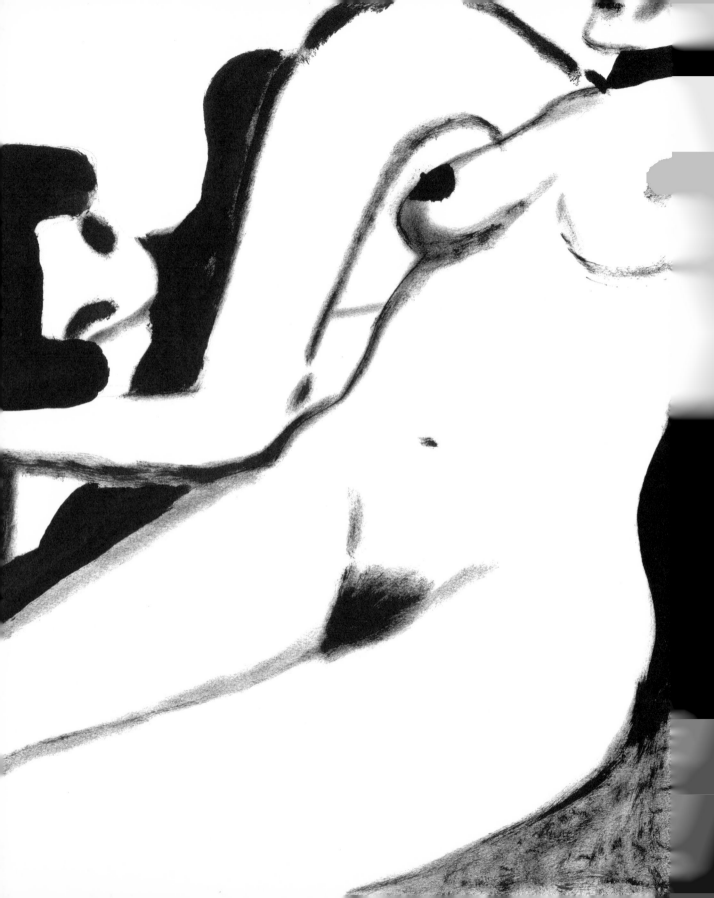

Liquid

I got three bottles
of liquid Valerie
from Italy
dose myself through these days of thunder
drop 1-10, on time
i have nothing but time
ml, mg, time.
sleep, nags me like a dog
but, my mind is open —
blind —find— freak— scolded
i am a science practitioner
and I've been here before
in a mad lab,
with auto body
focus
I've seen the writing on the wall
I've also seen the writing I've done . . .
i write BEAST! and YOU BEAST!
i can wail about lost love
i can sing to finding a new one
i can call the gods for a giant storm
or call collect to the "one" God in prison
i can hide like an elf
and make cookies all day
in a tree
i am the Godfather
i dose my sharp Italian suit
in diazepam
i think i'll make a call,
i'll call myself Anteros
and at night, come find you Nox
for you created my everything
i am a boy singing on a roof
singing a silly song about naming my
firstborn boy Rumpelstiltskin

i am a writer,
letting my fingers dance,
as an amateur performance artist.
each gulp is medicine
each swallow,
I'm a toilet
if i look soft enough,
i am a Greek god
the god of an island of pleasure and escape
only i cannot escape
this is "the tragedy"
my story is Grimm
put me in your book, give me a goose face
no matter how much water you drop on a stone
it will always dry and be thirsty
my heart yearns for you,
hence my thirst
you think i still have a problem?
sadly, it's you
sadly, its me wanting you.
to be with you.
i drop and i drop, and i drip
into a small portion of water
mix, and swallow
the liquid of love
spills everywhere
on my shirt, pants, my penis
i am rooting for nature,
yet i live in a small crack in the concrete
i could do more, but what is my reason?
if yours is a liquid lover,
then how can you hold her/him/it/them?
you are spilling everywhere
except fully near me
i don't want you as water

as liquid,
as chemical,
i want you whole & healthy
in Latin : Strong & Healthy
and in my arms
this world is crumbling
come to me whole
one liquid or another
you are all over the place, my love
i can't take much more
of this liquid lover

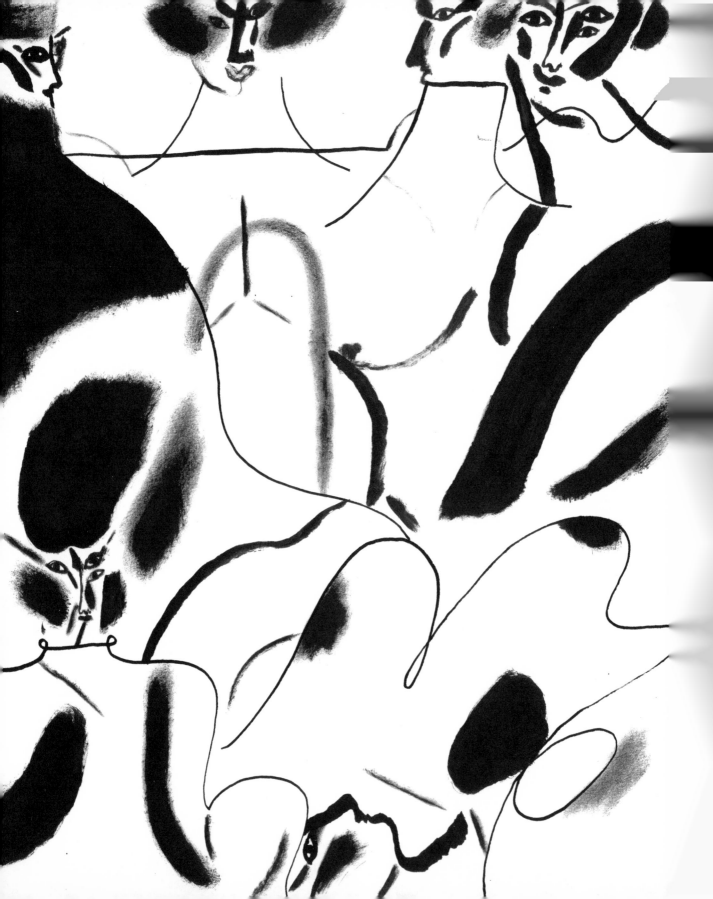

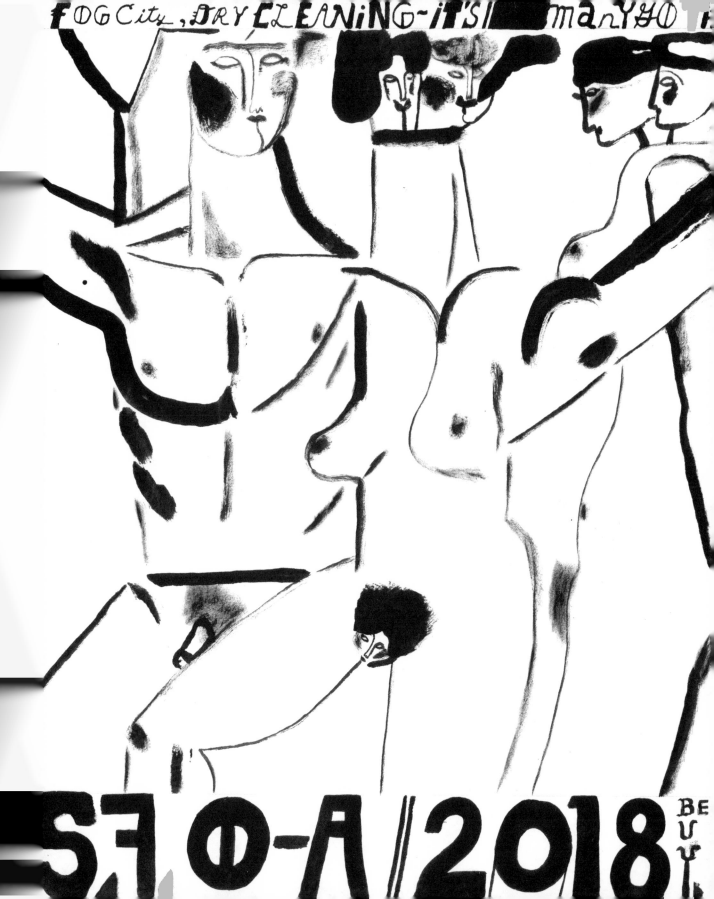

I See You, Freedom

zip goes the man on rollerblades
come here Papi
tropical Skittles
tonight i saw Pirates defeat Giants
i witnessed the whole thing
life is on the wire
a lover needs a love
a junkie needs junk
a gangster needs
Westside Sesame St.
the corner stores are lit up like Christmas
all the clerks wear beanies
some wear gloves
the merchants to the people
yea, . . . gimme that 1800
pack of Camels
paper towel to piss
I'm soaked in diet spite
i am diet cola
i can't get high now
if i did, i would hate myself
forever
but love myself
for a moment
i hear they throw bears to the wolves
and the bears tell jokes to survive
its 11:52 p.m., San Francisco
i could really use this walk
dodging cars, Lyfts, Ubers
bikes, motorcycles
it's a virtual game
of no crosswalks
full of senses and craft
Seals & Crofts
a breeze

and lights, so many lights
do you have a light, my brother?
sure do, one sec.
cucumber limousine
i have thoughts & dreams
i have a life that needs gasoline
i've beat demons, and fire scenes
if you keep burping onions on me
i'm going to leave
I'm sitting on the dock of the bay
watching a man on rollerblades zip away
honey, you're the one
I'm so trapped in your wax
i'd have to call the firemen
to hose me down
do the youths live here?
do the youths know more than i do?
long live the new beginnings of flowers
set to bloom, high, long and task
let them all laugh
wearing frowning masks
i understand all the trendy irony
the world is fucked
it got fucked in the ass
by an orgy of greedy white men
now, we all are traumatized
you know what freedom is?
it is drips of life, laughter, and making love
you know what freedom is?
rollerblading
down a city street
wind to your back,
in 2019.

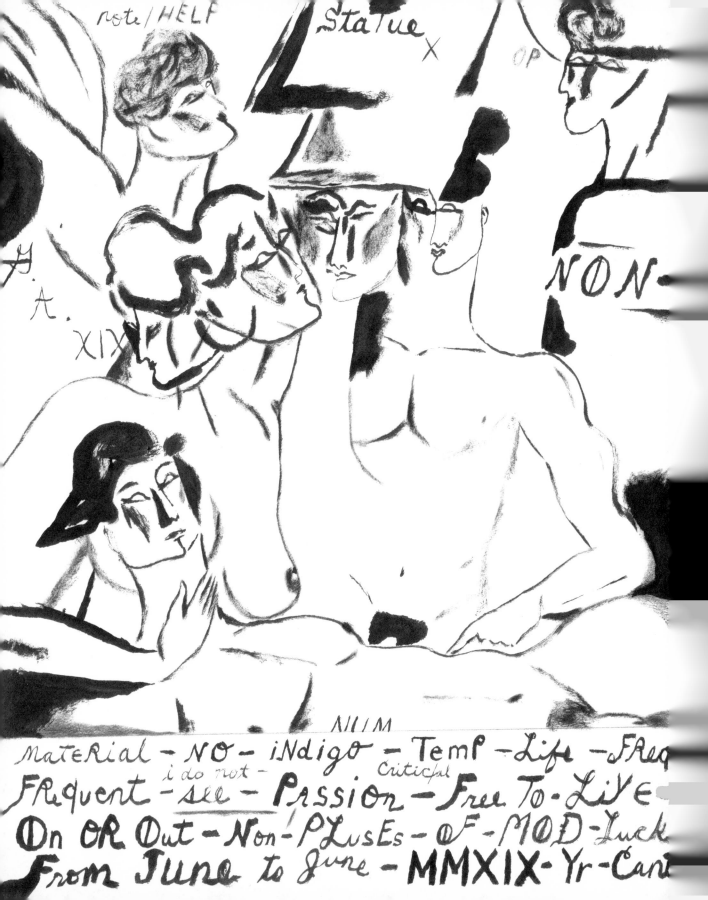

PubLic.freak.Out / Empty / WAT iS ThiS T 2018•Oh Curse HELP
incredible screaming VERy Noisey / PLSE - LVII X CUP Ⅱ
 Y
LOVE in

Rehab

I was sitting in the waiting room
of rehab
waiting to be seen by my doctor
in SF
the only other person waiting there
was Fat Mike
from NOFX
i recognized him
i like that guy

i come from an era where the girls
wanted to look like Da Brat
and Cortez and
Kings hats of black
the demon can sit on us all
and its weight
is fat

Info

411
She found ONE!
And,
I'm liquor store gum
A style
once loved by
The Trident spear of us
It's just a maze . . .
Just amazing how you carve a hole
In the heart
Have you ever had sex with someone,
just by looking in their eyes?
i have.
it was in L.A.
i blinked,
and there was a pregnant pause

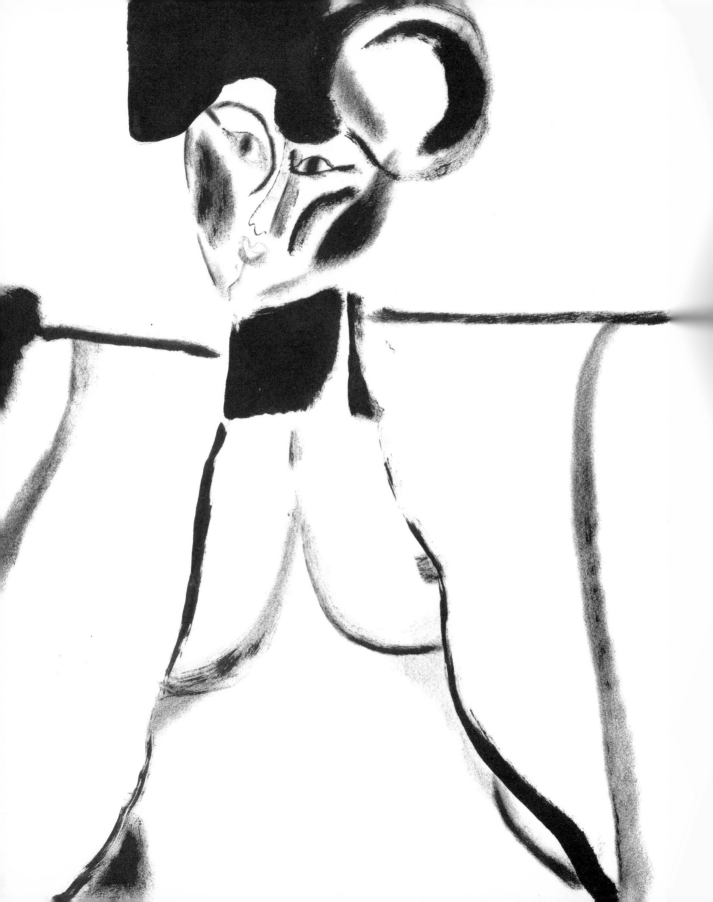

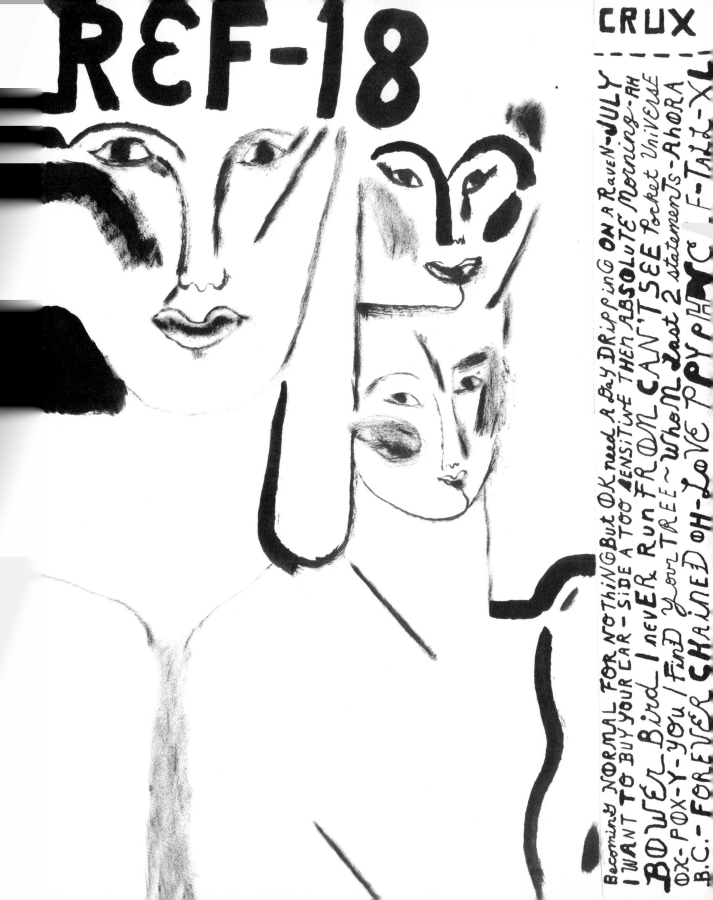

REF-18

CRUX

Becoming NORMAL FOR NOTHING But OK need A Bay DRIPPING ON A RaveN~JULY I WANT TO BUY YOUR CAR~SIDE A TOO SENSITIVE THEN ABSOLUTE Morning~RH BOWER Bird I neveR RuN FROM CAN'T SEE Pocket UNIVERSE OX-POX-Y-YOu I FinD YouR TREE~whoM last 2 statemenTS~AhoRA BC~FOREVER CHAINED OH~LOVE ↑PYPHYC↑ F-TaLL-XL

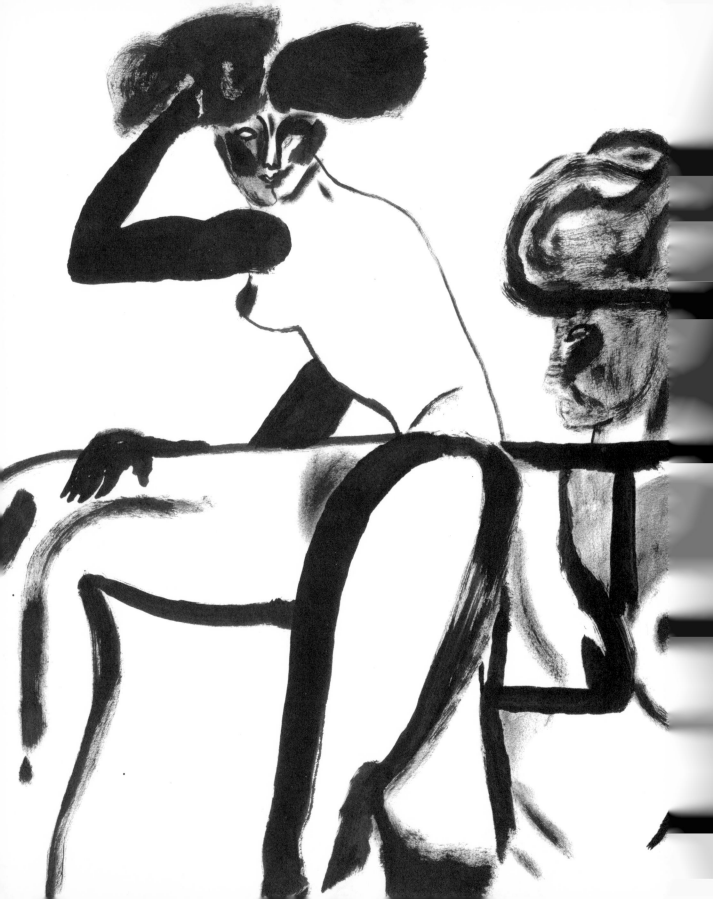

June / Panther Purple Midnight

I need you to be accurate
i need accurate
admittedly rightful,
I want genuine devotion
unconditional surrender
I avowedly pledge my car to you
my testament & will . . . to you
my tempo is accurate
I'm a panther,
with its purple highlights in the moonlight
so very accurate
look at my shoulders
pop! purple in the moonlight
so accurate
yet, compromise when i need
i want your arms, legs, breasts
i want you to be accurate
i can't make you,
or ever have designed you
your body, perfect and accurate
dream of statue, a statue dream
come get your piranha
sit on my face because you want to
i want your face
in my sky
high
no priests, no die
get on top, legs behind
royal jelly army
pull it back
big pink
i remember that big oracle on your lips
it saw me, and i listened
culture of cinnamon
fingers in molasses

greasy neck
leave a trace of your skin so i can sleep
prey for love, love for keep
put crickets in my ear
put them on my head
as long as you're accurate
honest
actual
loyal
Howdy, i'm your panther
not a cheetah
i have purple highlights in the moonlight
i'd crawl to you
stand on your stupid fucking ego
eat your brain
give it back with bow
with an arrow
love you forever
as long as you're in the mood, i guess
body comes with fact and truth
strictly correct and accurate
be accurate with your love
no ambivalence, or dour
your soup's not sour
it's milk from a goat
molasses to finger
i'm a panther
purple highlights
in the moonlight
i walk,
and watch.

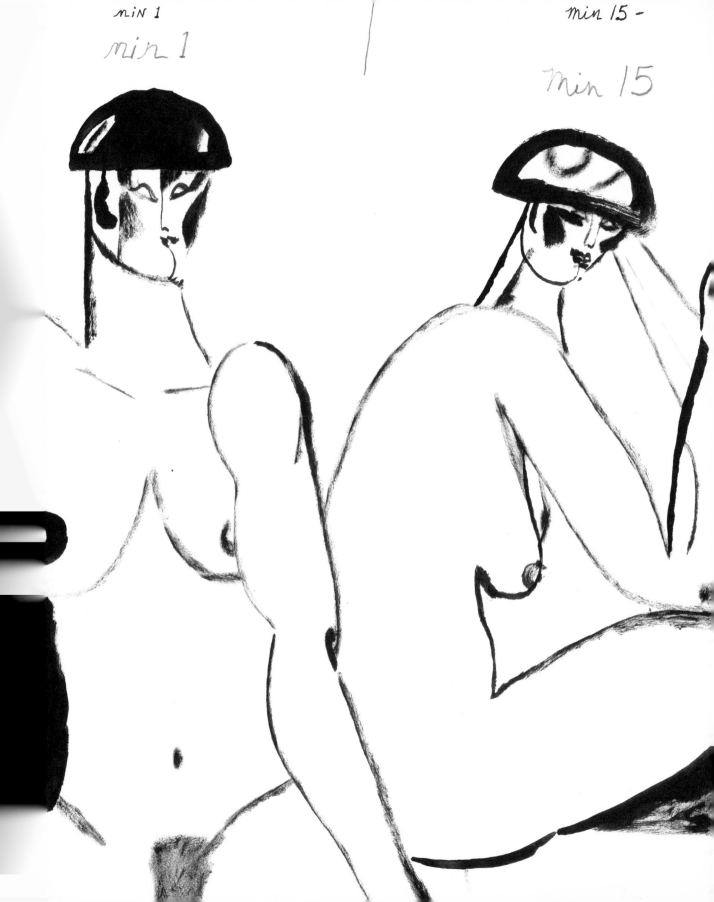

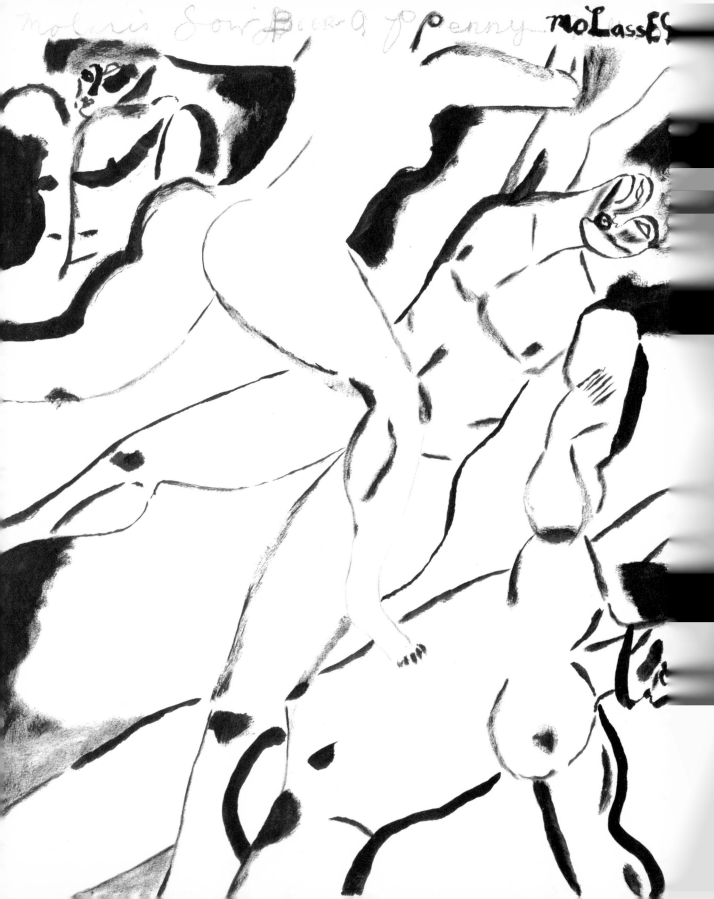

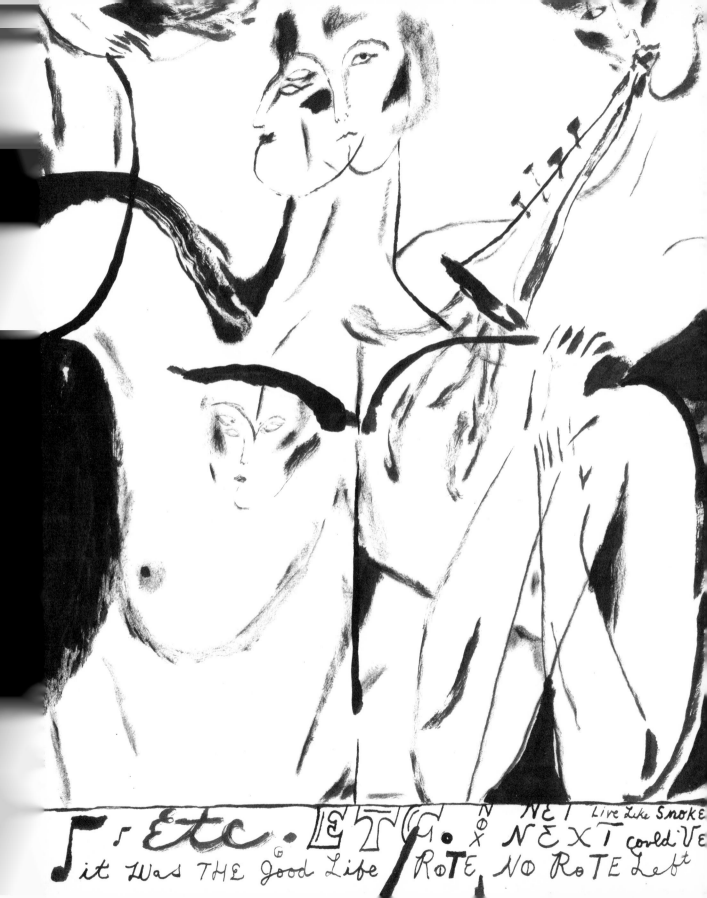

♪ ♪ Etc . ETC . N_O $^{N}_{O}$ NET Live Like Smoke
♪ it Was THE good Life / NEXT could Ve
RoTE NO RoTE Left

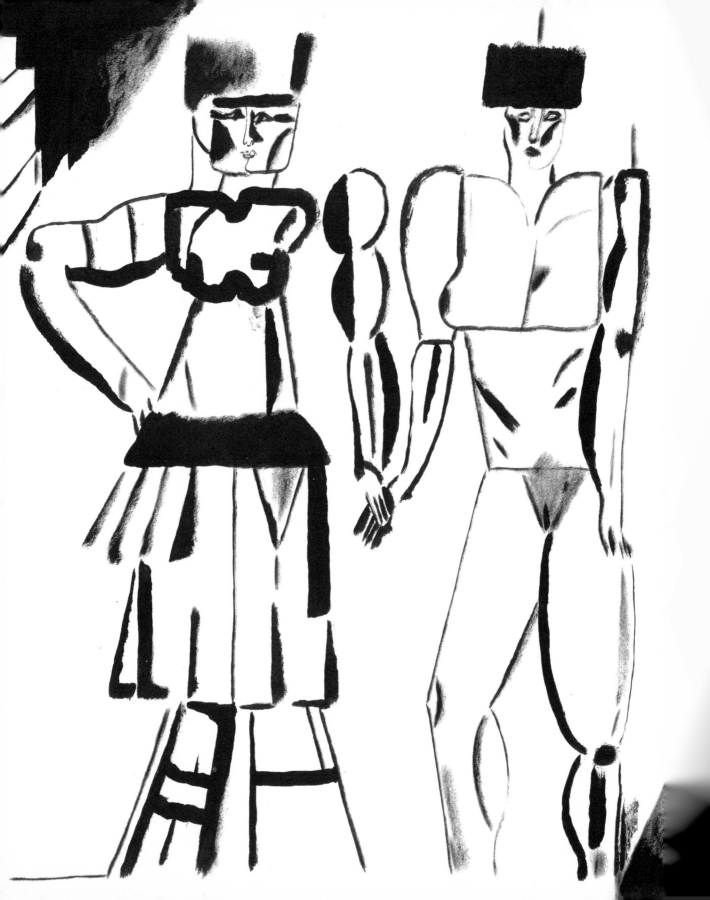

The Stone / Or . . . My the Troubles

After seven years,
of good luck & terror.
I've now started drinking
every night
fernet and Pepsi
or just straight
my skin has become dark white and ill
the pressures of love come on so easy
without the net of devotion, it explodes
and scatters, like a dandelion
the stone was created to make analogies for all time
the stone of a heart
the hardness throughout
the thirst of a stone
what's inside you?
is there no reversal?
the stone has been mulled over with weather,
and resentment,
and water.
insecure, that it has fallen
from a large cliff
your hometown football team is a cliff
you've made it on your own
solid,
but versatile
rest eggs on me
throw me to another park
another zip code
bring me to another country
show your friends, your loved ones
as solid as you are, you can roll at any moment
there is no true love to a stone
the stone of your heart
is old and callous?
a stone can break, and

become pebbles
Fruity Pebbles
collect your hard love
and fax it to me immediately
i want it on my desk yesterday
put a stone on top of it
to keep your love
from blowing away

First published in the United States of America in 2020
by Anthology Editions

87 Guernsey Street
Brooklyn, NY 11222

anthologyeditions.com

Editor: Jesse Pollock
Design: Bryan Cipolla

First Edition
ARC 080
Printed in China

ISBN: 978-1-944860-34-9
Library of Congress Control Number: 2020937300